Praise for Qorbanot

"*Qorbanot* is a vivid counterpoint between sensually anchored poems and evocatively abstract images. A few uttered lines here, a few painted lines there, make for a provocative artistic—as well as spiritual—offering."
— Annette Insdorf, author of *Indelible Shadows: Film and the Holocaust*

"These are meaty works—both poems and paintings alike. Not grisly, not violent, but thick with pain and perseverance. They are beautiful in complicated, interconnected ways, siphoned diligently from deep experience, whether personal, familial, or historical. Together, Kaplan's words and Kahn's images are indelible."
— Aaron Rosen, Director, Henry Luce III Center for the Arts & Religion
at Wesley Theological Seminary

Qorbanot

Qorbanot
Offerings

Poems by
Alisha Kaplan

Art by
Tobi Aaron Kahn

Foreword by
James E. Young

Essays by
Ezra Cappell
Lori Hope Lefkovitz
Sasha Pimentel

The author and the artist gratefully acknowledge funding support from the Ontario Arts Council.

ONTARIO ARTS COUNCIL
CONSEIL DES ARTS DE L'ONTARIO
an Ontario government agency
un organisme du gouvernement de l'Ontario

With gratitude to Ben Z. Post for his generous donation for the color images in Qorbanot.

Cover image:
Study for RYSTA
Acrylic on handmade paper
1996

Published by State University of New York Press, Albany

For information, contact State University of New York Press, Albany, NY
www.sunypress.edu

Library of Congress Cataloging-in-Publication Data
Names: Kaplan, Alisha R., author. | Kahn, Tobi, 1952- artist. | Young,
 James Edward, writer of foreword. | Cappell, Ezra, 1971- author. |
 Lefkovitz, Lori Hope, 1956- author. | Pimentel, Sasha, author.
Title: Qorbanot : offerings / poems by Alisha R. Kaplan ; art by Tobi
 Aaron Kahn ; with a foreword by James E. Young ; and essays by Ezra
 Cappell, Lori Hope Lefokovitz, Sasha Pimentel.
Description: Albany : State University of New York Press, Albany, [2021]
 | Series: SUNY series in contemporary Jewish literature and culture |
 Includes bibliographical references.
Identifiers: LCCN 2020038216 (print) | LCCN 2020038217 (ebook) |
 ISBN 9781438482927 (paperback) | ISBN 9781438482910 (ebook)
Subjects: LCSH: Holocaust, Jewish (1939-1945)—Literary collections.
Classification: LCC PN6071.H713 Q67 2021 (print) | LCC PN6071.H713
 (ebook) | DDC 808.8/0358405318—dc23
LC record available at https://lccn.loc.gov/2020038216
LC ebook record available at https://lccn.loc.gov/2020038217

10 9 8 7 6 5 4 3 2 1

Contents

Foreword

MIND POURS ITSELF INTO THE OPEN SPACES ON THE PAGE BETWEEN
Alisha Kaplan's exquisitely intimate, gemlike poems and Tobi Aaron Kahn's myste-
rious, handwrought miniature paintings. As a poem like "Sin Offering" (41) invites
readers to imagine and then say aloud (or subvocalize) its absent lines, the paintings
silently invite the poems to "speak" for them:

> if you say don't imagine a golden calf
> there she is
>
> if you say don't picture me naked
>
> never to think of sin
> is to stop the flow of blood
> is to bind ocean into desert
>
> the more I try to control
> my thoughts the wilder

The poem's spaces between stanzas open up into the larger canvas onto which we
project what is in our mind's eye, what it is we expect to hear next. Poems and
images share an otherwise blank canvas as they work through together the nag-
ging, perhaps unanswerable question posed by this volume's title, *Qorbanot*: In the
Deuteronomic tradition, is every sacrifice, no matter how great or little, also an
offering to the divine, a compensation for our sins?

In the mini-currents of his brushstrokes on handcrafted paper, Tobi Aaron Kahn emphasizes movement and process over fixed and static art. In his *Study for* RYSTA (62), twinned with the poet's "Heirlooms Offering," the artist offers red blood cells, pulsing with life, as a living, ongoing sacrifice. The poem and image together are art-as-healing, not a sacrifice in and of itself but an offering of creation, the afterlife of sacrifice.

Beginning with the First Hurban (destruction of the first temple in Jerusalem in 587 BCE), continuing through the Second Hurban (destruction of the second temple in 70 CE), and even continuing with what some would call the "Dritte (third) Hurban" (the Holocaust), all destructions were to be explained by the basic covenantal paradigm: from sin to destruction to redemption. After the Holocaust, however, this traditional cornerstone of Jewish faith and covenant has become a stumbling stone for a generation unable and unwilling to explain such a national catastrophe with the traditional lament, "Because of our sins, we were destroyed." Nor has this postwar generation been able to accept that such terrible destruction can be divinely or humanly redeemed at any level whatsoever. Neither by art, nor by historiography, nor even by the birth of the State of Israel. How does this an-tiredemptive generation continue to abide by its covenant with a Jewish God of History, founded on remembering what God has done for (and to) His people?

In his brilliant and foundational literary history, *Hurban: Responses to Catastrophe in Hebrew Literature* (1984), the late and beloved scholar and teacher Alan Mintz plumbs this theological conundrum and suggests that even classical rabbinic re-sponses like the book of Lamentations have built into their poetry deeply ingrained questions about their adequacy to confirm the covenantal paradigm. In his clear-eyed words:

> Destruction, according to the covenant, is a sign neither of God's abandonment of Israel and the cancellation of His obligations to the people, nor of God's eclipse by competing powers in the cosmos. The Destruction is to be taken, rather, as a deserved and necessary punishment for sin, a punishment whose magnitude is in proportion to the transgressions committed. As a chastisement, the Destruction becomes an expression of God's continuing concern for Israel, since the suffer-ing of the Destruction expiates the sins that provoked it and allows a penitent remnant to survive in a rehabilitated and restored relationship with God. (3)

But if a postwar, antiredemptive generation of artists and poets remains averse to recapitulating the cycle of sin-destruction-redemption in the face of massive de-structions like the Holocaust, it may still be open to finding some sort of artistic

redemption in response to the small losses and micro-destructions of daily life. These are the *qorbanot* I believe Tobi Aaron Kahn and Alisha Kaplan have in mind as they ask whether their acts of art and poetry can redeem such losses without fully compensating them—or whether it is ever possible to articulate the voids left behind without filling them in. As this volume's poet, artist, and contributing writers make so clear, the answers to these questions necessarily lie in the open spaces between words and images.

—*James E. Young*

I

Instead of bulls we render our lips.

—Hosea 14:3

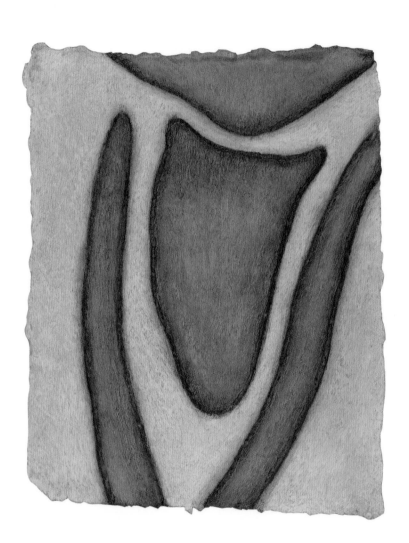

GRAIN OFFERING

am I heretic
as I tender to my beloved
seeing no wrong in it

afternoon prayer
a bed in a field

the root of *qorban*
is to draw near

all I have to offer
is myself

I burn a fistful on the altar
a sweet aroma curls in the air
not rising beyond the date palms

II

Ain't nobody here but us chickens.

—1946 song by Louis Jordan and his Tympany Five

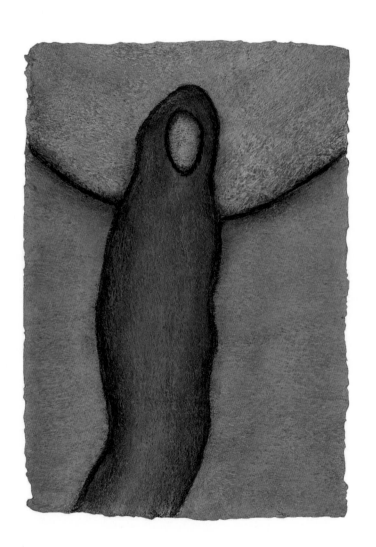

GUILT OFFERING

thank you for making me a woman for letting me reside in the book of life inside of which is the pizza shop I was afraid to enter wearing jeans the movie theater I was afraid to be seen at with a boy the shower I was afraid to sing in the chair I was afraid to sit in lest my skirt rise my sex I was afraid to look at till I was twenty-five thank you for teaching me to be afraid of the stranger for making the shoulder something to look over bless you thank you thank you

PEACE OFFERING

my vow is my palm
I place between the goat's horns
before it's slaughtered
as if to say I'm sorry

the priest waves the goat round his head
right shoulder and breast allotted to him
then removes the fat from entrails flanks kidneys
lobe attached to the liver above the kidneys

and the fat goes to you
no
to the fire

I know this smoke ascends
no higher than Mount Meron

and my word was carried out
by my unmighty hand

still
to the feast I'll wear my finest dress

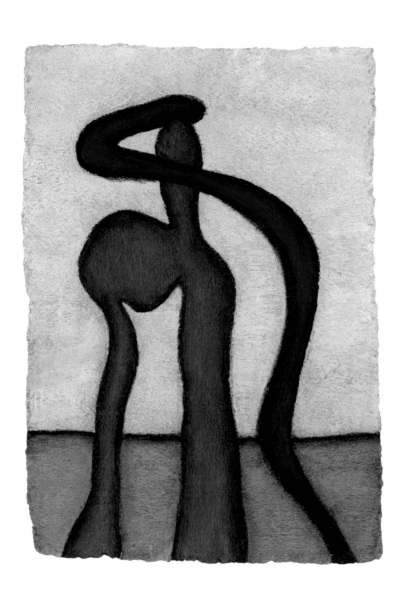

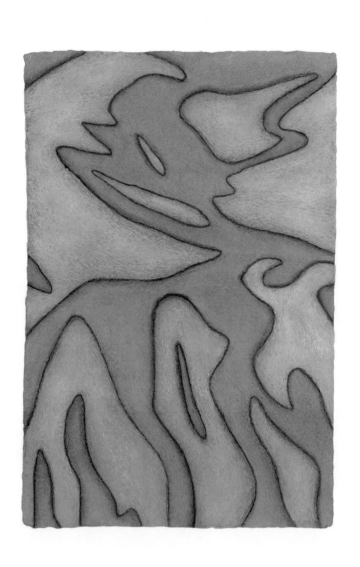

MASADA OFFERING

The bus driver dropped us off in the middle of the desert,
nothing in sight but the three of us,
eighteen years old and running away from Jerusalem
to climb as the sun climbs the fortress
but we couldn't yet see the way, the dark was thick
and when I looked up, my god, I couldn't find the familiar
constellations, there were stars upon stars though everything was still hidden
down where we were. So we lay on the sand and feared the creatures that scuttled,
was there howling too, except M, she wasn't afraid,
maybe we slept or we talked or not, until the dark thinned, the cliffs appeared,
we hiked up the snake path to Jimi Hendrix.
B tells me a decade later she was pleased with her song selection,
says in retrospect we should have been surprised
the driver thought it was okay to leave teenaged girls in the middle of
but this was Israel, and Jerusalem was more dangerous than desert,
there were people there, despite which we took city buses against our parents' orders,
but we didn't think of that, we thought of the wide open sea of sand
where no one was watching. We returned to Jerusalem
and we returned to seminary like the good girls we were meant to be.
I haven't spoken to M since that year, she's married with a number of kids
and still religious, but B and I are another story, never good
at doing good, we're *off the path* our parents say.
She sends me photos of the black irises we used to visit in the North
and misshapen trees in Tel Aviv where she lives with a man she can't decide
to break up with or marry, and I'm nowhere near,
I'm in a valley of California mountains, temporarily. Hiking down
a trail that rivers, I remember Masada, and wonder why I'm always more afraid
of falling during the descent. I return to that night often,
though truth is, I can't recall much about it.
What I have is the feeling of being released into the wild,
the dark and shock of stars,
the zig-zagging path and *Are You Experienced*,
I don't remember coming down, don't remember
the sunrise, it was probably beautiful.

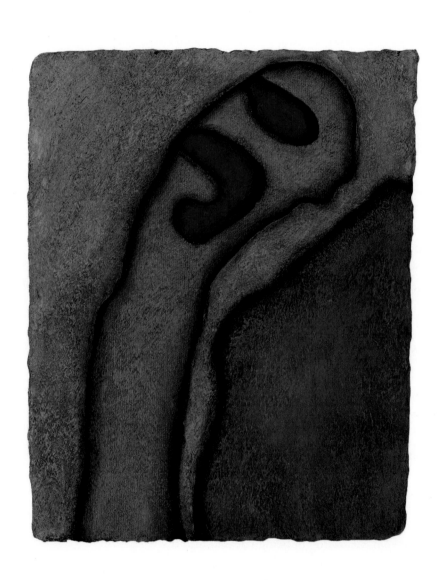

GUILT OFFERING

because I might have possibly there's a chance
I tasted flesh that is forbidden
I feed the sons shamefaced coins
and a ram without blemish

blood dashed
on altar sides

they speak of your mercy
letting me live
as if it's not in my hands
around my hands is rope

they taught me in school
constraint is freedom

only carry when you permit me to carry
and do not wander beyond the fine wire
wrapping this city

GUILT OFFERING

(I did I tasted his skin
 and traced his skin
pressed my ear to his skin
 breathed in his skin
 witnessed his skin
 his christened skin
with all the senses you gave me)

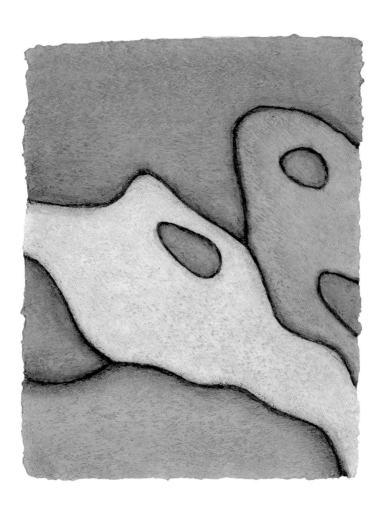

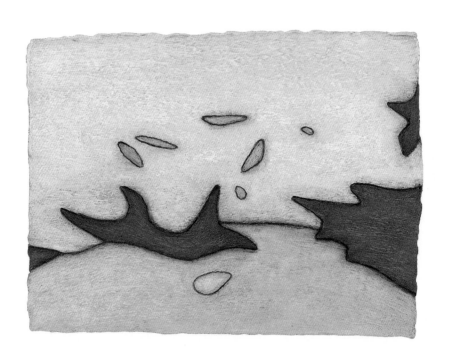

PEACE OFFERING

am I guest or host
at this meal of wine bread oil and salt
with what's left of the meat

dine on my promises
strewn over the temple steps

vow: return to question

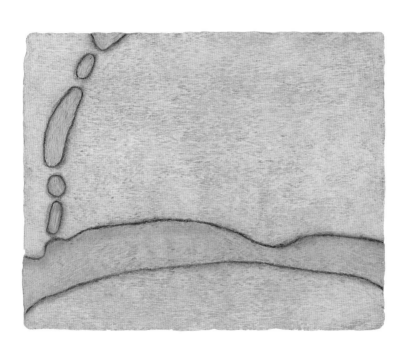

III

A righteous man knows the soul of his animal.

—Proverbs 12: 10

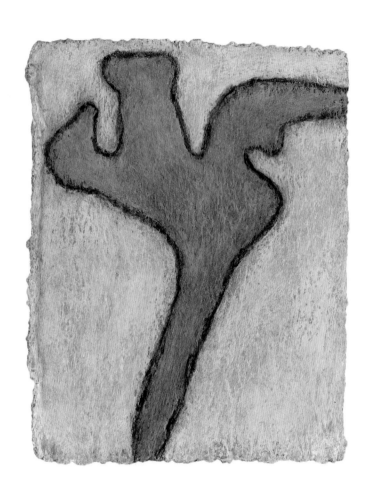

PRELINGUISTIC OFFERING

> What is the highest nature? Man is the highest nature....
> The question is this—Is man an ape or an angel? (loud laughter.)
> My lord, I am on the side of the angels (laughter and cheering).
> —*Benjamin Disraeli, in his speech "Church Policy,"*
> *delivered at Oxford in 1864*

chimpanzees dance
 at the base of a waterfall
with is it not possible a feeling like awe

only rarely is a body without
weight and shadow in a word angelic

you wouldn't think a woman could forget
 how to dance

if there were no text in temple song
 my hips might sway
 over and
 above

you wouldn't think a woman could
but I have forgotten
 what the body is to do upon waking

I would like to be a different kind
 of lost
 to the side angels are not

within and
 without words
carried on the back
 of first light

SIN OFFERING

around the corner from my Crown Heights apartment,
nested between auto repair shops: *señorita,*
meet your meat: ducks, pigeons, rabbits, quail
stacked high in packed cages, mangled chickens
peck off one another's feathers,
eat their own eggs: blunt ritual:
chosen, weighed, butchered, dressed:
a man power-washes the back room,
in the side room listless goats and donkeys slump
under fluorescent lights: and I am in no place
to condemn

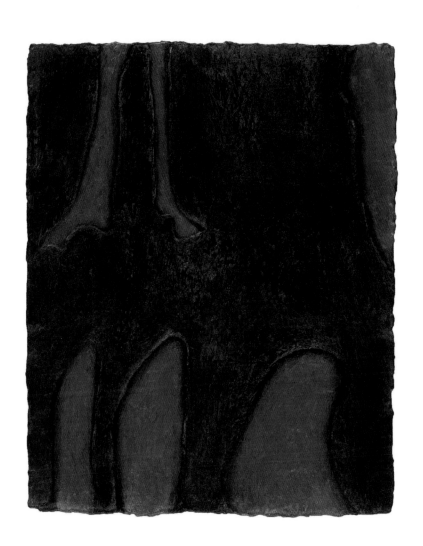

SIN OFFERING

I buy a Dutch oven to serve as my one treyf pot. It's beautiful: a Le Creuset, more expensive than any other I own, in a butternut squash color that summons stews and chicken paprikash. If the family finds out—there it is, again. The fear. I swallow.

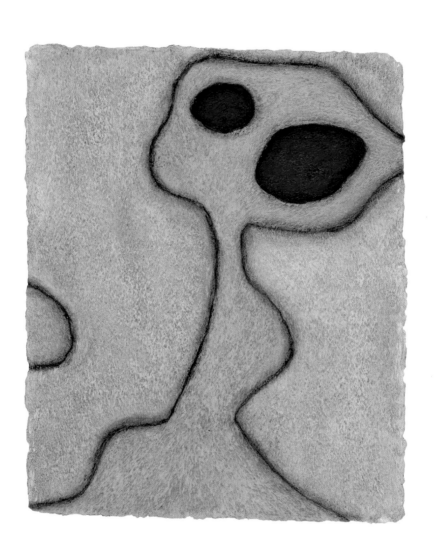

OFFERING FROM WHICH THERE IS NO TURNING BACK

the first man born
brings the first sacrifice is
the first to kill a man with the first blade
from the sharpened jaw of a donkey
is the first time *sin* appears
while *in the beginning* begins with the second
letter of the alphabet and if I snap
the chicken's neck

> *This is how it's done:*
> *Catch the chicken while it's not paying attention*

you won't catch me praying like my brother
in Hebrew Abel means *nothing*
which is what my prayer consists of as in I don't
or it begins and ends in silence a field between

> *and hold it upside down by the ankles.*
> *This prevents it from pecking you or escaping.*

you say to Cain *sin lies at your door*
as though sin has a body
if I were to dissect its anatomy what would I find

> *Expect the chicken to flap around. Continue to hold it.*

I build a doorway between two fields
I build my altar and after

> *Catching the same chicken again will be difficult if you let it go.*

if I snap the chicken's neck
what door

> *Hold the feet and neck firmly.*

all the doors I've ever loved were painted red
if I snap the chicken's neck will it open or close
a door will I be unhinged

Pull down on the neck, then twist it upward, fast and hard.

what if I enjoy it
my hand around the neck
is this the sin you speak of
Cain says to Abel *let's go out to the field*
and only the grasses know what happened

 You'll feel a fracture,

I don't know what happened
to all the doors I've ever loved

 then the chicken will begin flapping its wings.

red after red till the whole house was red
and the door was painted green
and what will happen out here
if I snap the chicken's neck

 This is a reflex—the chicken is not still alive.

you may no longer find me kneeling at your door

 Some people hold the chicken until the twitching stops.
 Others let it run around. This can be disturbing.

I had thought of the Cain and Abel story as history
but now it is no less than a metaphor
for the evolution of civilization
settled farmer replaces nomadic shepherd

 Once the chicken is dead, cut its jugular

in this revolution of the sun
I settle into the inevitability of

 and hang it upside down in a bucket to drain the blood,

and the ceremony of slaughter

then proceed to pluck and dress it.

better I know blood on the hands

If you don't know what you're doing,

my hands

the process could be difficult and drawn out.

the story doesn't close in the field
a fugitive Cain wanders
builds the first city
builds a house and lives there
until it collapses on him

Killing a chicken should be quick, clean, and simple.

though Medieval legend has him settle on the moon
with a bundle of twigs

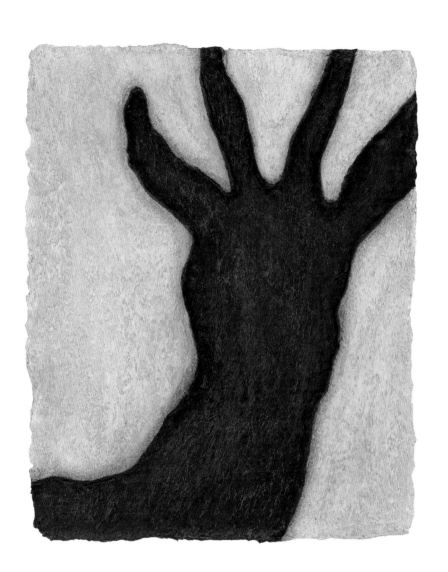

OFFERING OF THE UNCLASSIFIABLES

I was taught to shoo a snake and say *away omen away*
if the premise stands that every animal has a purpose
where does that leave me and if that which defies
classification is cast away where does that leave you
are there places for us to live other than land air water
away omen and if the snake's cunning is the same word
as my naked *away* but what harbinger is not manmade
the rabbis say the following things are loathsome
witchcraft unsanctioned sex murder forbidden foods
I say this is getting off on a catalogue of the illicit
I say incorrect my mistakes I say unclean make me
for I get down on all fours and go on the belly

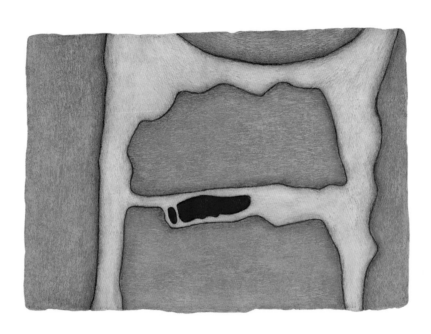

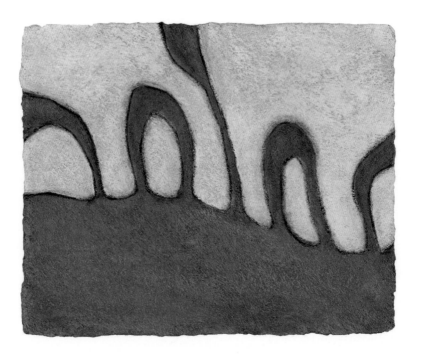

BURNT OFFERING

what if song entered the mouth instead of leaving it

and what of the sacred nostrils

you say this is not death but a transformation
from one kind of existence to another
a pleasing odor to you

within me are openings openings
and hollows hollows

all that can cross a threshold

food seed waste incense ashes
and the skin laps up every touch

vow: when the Third Temple is built

 no

 when the orchard bears
 I will bring the first fruit
of pawpaw and serviceberry
 common persimmon and Canada elderberry
a third to my lips a third to my loves
 a third to the birds and beasties

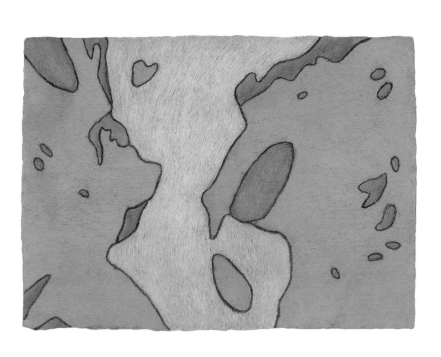

IV

because I prayed
this word:
I want

—Sappho

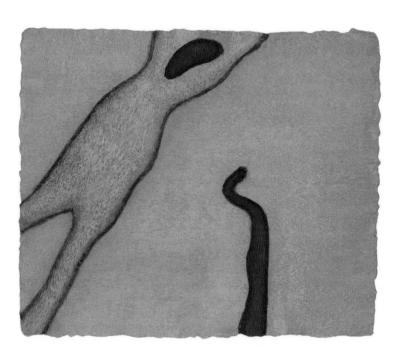

SIN OFFERING

if you say don't imagine a golden calf
there she is
if I say don't picture me naked

never to think of sin
is to stop the flow of blood
is to bind ocean into desert

the more I try to control
my thoughts the wilder

GRAIN OFFERING

I learned to knead dough on a farm in Ireland where I was the only Jew for
miles and for the first time exotic I made elderflower cordial built a scarecrow
on the Sabbath I climbed Hungry Hill covered in mist and sheep and climbed
waterfall rocks till I reached the cairn at the summit this was the highest I'd ever
and I came down drank cider ate crisps shared a bed with a French boy who
didn't like to French kiss and hitched a ride home in the morning

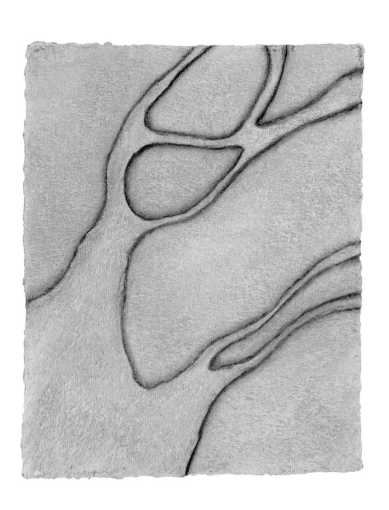

SIN OFFERING

you do not want
the blood of my bulls
as the verse says
the blood in my bowls

for I harbor tides
of wicked
was just last night uncovered
with intention

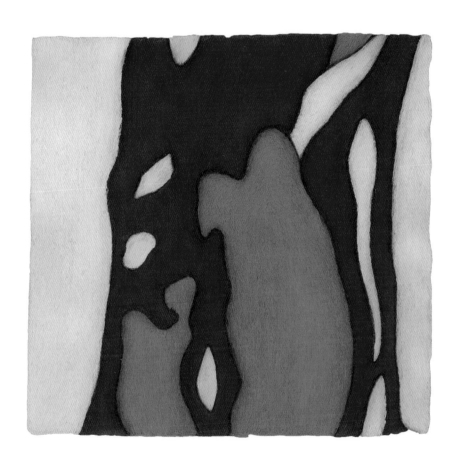

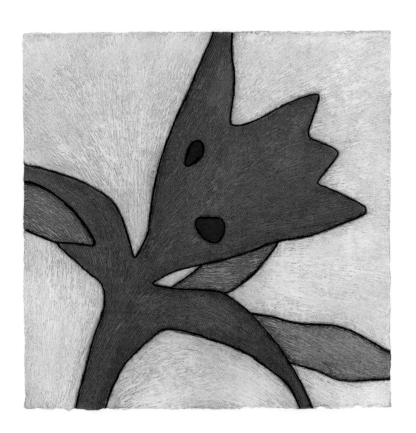

OFFERING IN WHICH AN ANGEL APPEARS TO MOSES
IN A BLAZE OF FIRE FROM THE MIDST OF A BUSH

after Yehuda Amichai

when they were alone
between two gulfs and a sea
she said his name
and said his name

he answered *Here I am*
and meant *I am yours*

he took off his shoes and met fevered sand
for this was holy ground

here
and here
he answered her

in awe of this new wilderness
he hid his face

he was not a man of words
in that present or that past
only then did he ask
what is your name
and she answered
I am as I am

in doubt he placed a hand to her cheek
as if it were snow

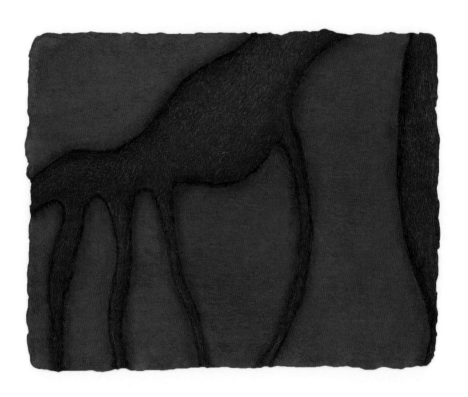

SIN OFFERING

if your animal side gets the better of you
animal is the better of me

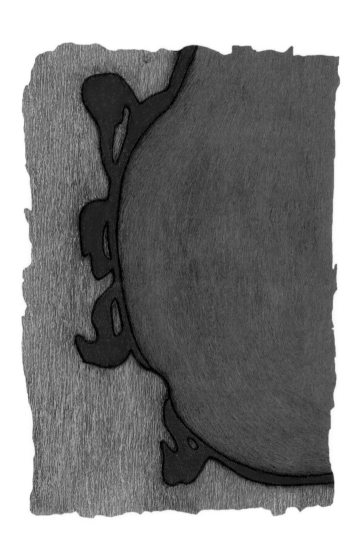

BURNT OFFERING

you ordered me to bring a lamb in
my stead and punish it burn my liver
kidneys fat and caul completely utter
sublimation of volatile spirit to a
higher I will not go up am entirely
this creatural a sum of all born before
me fauna earth sea a-sea earthen faun
I will not go up in smoke

OFFERING TO THE LOST POET ROSEMARY TONKS

I too chose badly with lovers
 and wandered longitudes
 though I away from conviction
 —but which Rosemary are you in death
 whom do I address

I too—trespass
 claiming to know your hidden days
 the small explosions housed
 in a boudoir of bad angels—
cloister in the cafe
 to drink a cup of tea among
 but not with

to excite from afar—do I dare speak of
 the cast-off roses (the pages)

o inmate to omen
 what daring in your blooms
 and in burning them

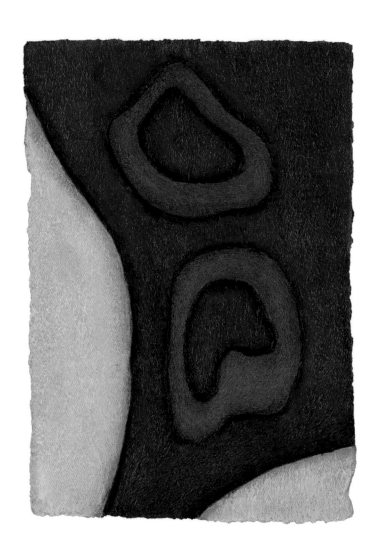

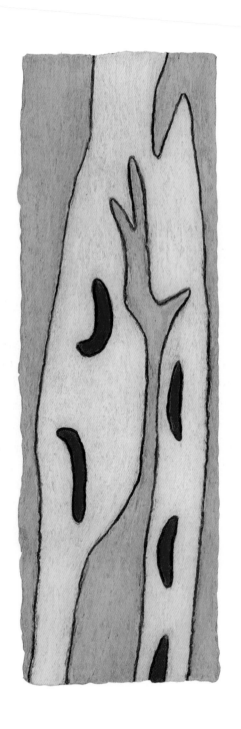

HEAVE OFFERING

a daughter of the sons of Aaron does not slit throats wear the skins have
her feet washed nor do I want to claim such a right all she's afforded
is the breast the thigh four loaves permission to consume the firstborn
permission to stand on the ground covering the dead but that isn't her
role her role is to marry inside the tribe she is placed inside a tent
between honor and margin her role is not to defend against night terrors
or to bless a long journey but try and stop me from raising my hands
and parting my fingers or placing a face unto my face or a plash of milk
into stew you can have the foreleg the cheeks the fourth stomach am I
I am the daughter of a priest no longer

BURNT OFFERING

at the entrance to the tent of meeting a postpartum woman must bring
a young pigeon and a year-old lamb to cleanse her of impurity

hasn't she already sacrificed
her body

to a tiny god whose fist
tightens around her finger

and hasn't there been blood enough
for the holy men to wade in

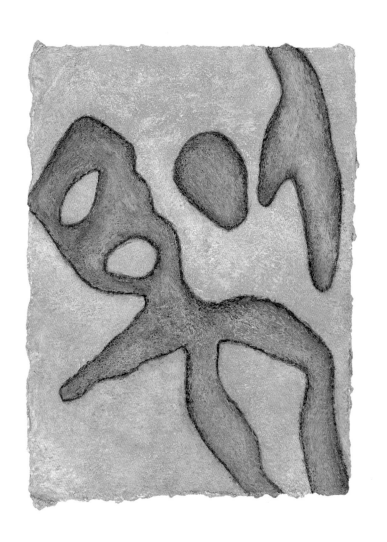

vow: every
 every time I say
 every time I say your name
 is in vain

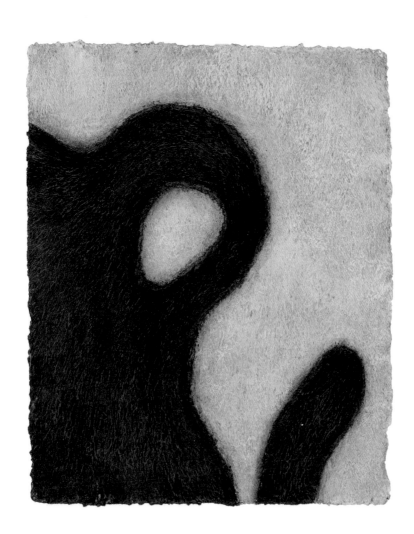

V

Now I hardly ever pray.

—*Dorothea,* Middlemarch
by George Eliot

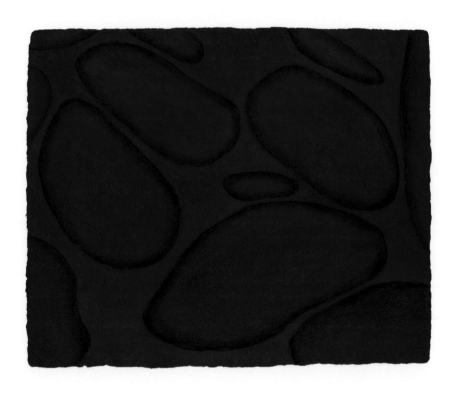

HEIRLOOMS OFFERING

The prayer book my great-grandfather gave my great-grandmother
on their anniversary, she had hoped for pearls. The big ruby ring
my grandfather sported on his pinky before the war, given to my mother
at eighteen who wore it with a miniskirt and red wool sweater.
My grandmother's wedding band, lost stuffing a DP camp mattress
the day after the ceremony. Her first diamond, my grandfather
saved up for years. She would have preferred a prayer book.
My mother's wedding band, lost down the drain at a Holiday Inn,
honeymoon day one. Rubinstein means ruby stone, my mother's name
she wishes I wore. Emerald, my birthstone, believed to strengthen
memory and give the gift of foresight. Most often I wear
my grandmother's thimble, find her in the tarnished grooves
that protected her thumb from the needle.

GUILT OFFERING

it is written send away the mother bird
before taking her young

people often mistake me
for a vegetarian

there is much evidence
we are your greatest solecism

have done more harm
than any other creation

the first stuffed toys were covered
in the skin of stillborn calves

if incapable of sin
how can animals be punished

they likely don't believe
in the supernatural

or see their faces
in the moon

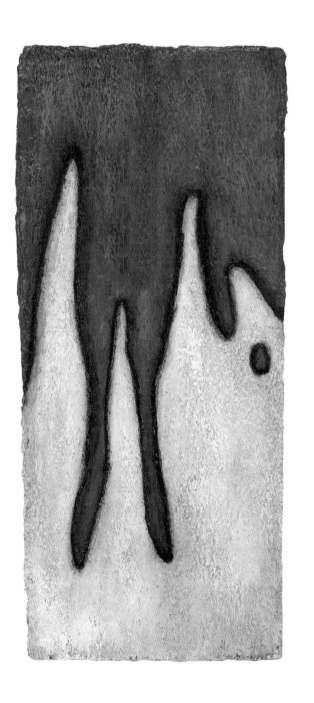

OFFERING TO MY MOTHER

A man left his four-year-old on the Texas I-20
after nearly choking him to death, as per God's
instructions. An Arizona woman tried to drown
her toddler in a puddle, Jesus told her to.
On what would one day be the Temple Mount
in Jerusalem, a man bound his adult child,
laid him on a pile of wood, knife raised—
Offer up your son. Every Rosh Hashanah
I sit in synagogue and hear the story.
This is how we begin. This is how we begin?
If you ask me, Abraham failed the test.
How much sacrifice is too much?
When Sarah learned her son had been taken,
she screamed six times. There is no coming back
from the binding and the scarring. I am the child
of a woman who didn't have a childhood
but who could blame her parents
for not knowing how to comfort after
she'd wake crying from a nightmare
when their own overwhelmed them?
I remember waking up crying after
dreaming she'd died and then yelling at her
for overboiling the eggs or something equally
trivial. When Abraham and Isaac returned,
they found Sarah had let out her last
and where they returned was no home.
A body can be a home. My mother
had two C-sections and then she had me,
who tore her open without intervention.
Unlike my forefather, the beloveds I can touch
always come before those I can't. Yet,
why do we hurt those closest to us?
The command to Abraham came from no God

66

of Mercy but of Judgment. I've blamed
my father and his father for passing down
the locus of hopelessness, which
has made me cold-blooded, most of all
to my mother. But these men are no excuse
for my wormwood tongue, no excuse.
I never once heard her raise her voice.
Do we hurt those closest because they will,
we trust, always be within reach?
My mother believes to be a mother
is to protect your child from harm
and forgive all your child inflicts. How
can I deserve this love? I want to tell her
there is a time to suffer in silence
and a time to scream.

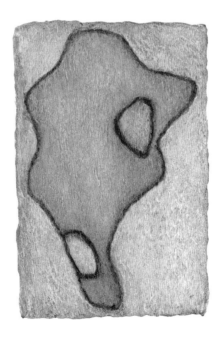

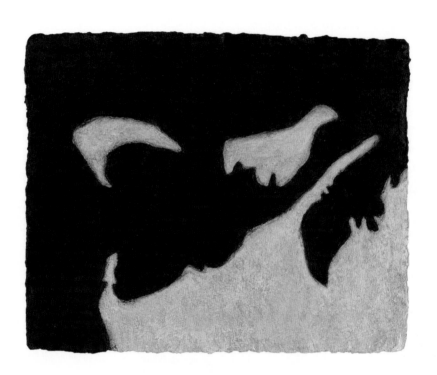

BURNT OFFERING

The priest holds the bird in his right hand and with
his thumbnail pierces the back of the bird's neck,
cutting through the spinal cord, neckline, esophagus
and trachea, and the surrounding flesh. He presses
the bird against the altar wall and squeezes out its
blood, before completely detaching the head.
He removes the crop then tears the bird
open by its wings.

gall to think a life can be lorded
by anyone any one

I'm haunted by the cooing
of old world turtledoves

BURNT OFFERING

The last time my grandmother saw her father, he blessed her and said:
Eat whatever you are given and be among the first to offer to work.

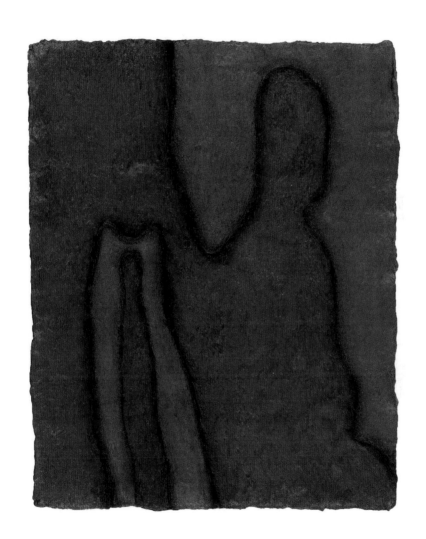

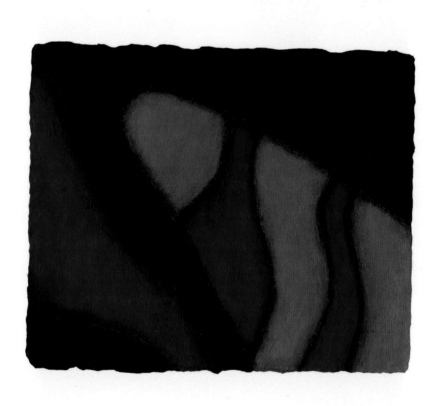

BURNT OFFERING

Her job was to clean the watchtowers.
From the windows she could see the yard, kept pretty
with flowerbeds, and rabbits and chickens to pacify
the children. She saw the squat, windowless building,
its chimney continuously belching black smoke.
She smelled the burning bodies, saw the sky turning red.
Her name was Judit.

DINNER TABLE OFFERING

We hate hide-and-seek. Grind our teeth at night. Dream about running and running. Dream about our parents dying. Wonder, if we had to choose, whom would we save. Scold ourselves when tired or hungry or cold: *This is nothing, think about what our grandfather suffered.* We sit facing the door in restaurants. Save the smallest bit of leftovers though our fridges are always full. And though later in life we will regret not committing to memory every detail, we give each other the *here we go again* look when our grandmother, during dessert, for the hundredth time, in the same voice she uses to describe her trip to the supermarket, tells us how she almost got hanged in Auschwitz for picking wild blackberries.

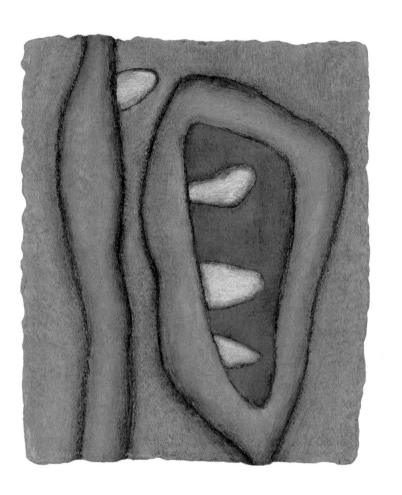

vow:

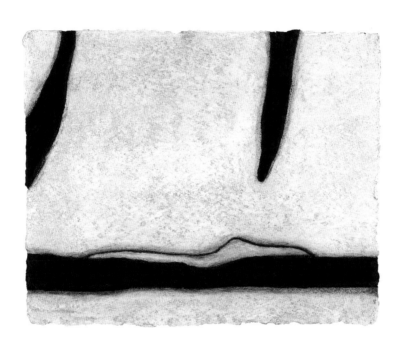

VI

May I be worthy of my meat.

—Wendell Berry, "Prayer after Eating"

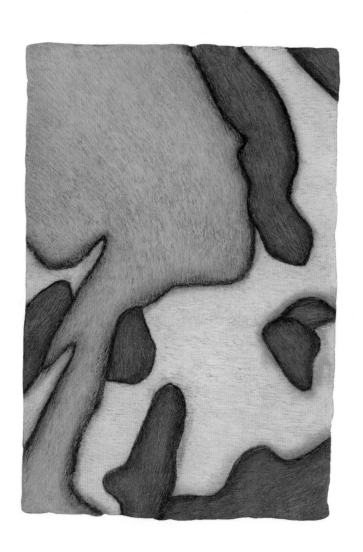

OFFERING OF TEN DRESSES

One American soldier found her an old sewing machine
and blue-and-white checkered linens from abandoned S.S. barracks.
She cut up the cloth on which Nazis had slept and sweated. She sewed.

May 5th, 1945, the first photograph in years:
Two rows of young women, flesh returned to their faces, in matching
gingham dresses with puffed sleeves, collars descending into perfect points,
pattern elegantly diagonal, there, on the breast pockets.

At her kitchen table, a plate of rugelach between us,
she points to the photograph:
We began, mamaleh, to be human.

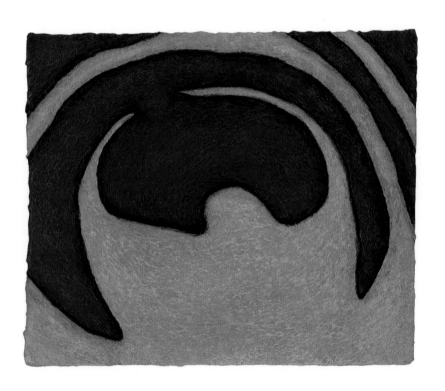

OFFERING TO AZAZEL

how to measure a person:

 by deeds or misdeeds
 by coins or logs of oil
 by size or frequency of sacrifice
 by company kept or distance strayed

homing:
 the phenomenon whereby cells
 migrate to the organ of their origin

 what organ am I
 what specific vital function
 within the tribe and what is my tribe

homing:
 an animal's ability to return to a territory
 after traveling a length away from it

 my people were your people are
 the chosen could not be my people

skin:
 to remove the very thing

 I free the scapegoat to an open field

 where is the place of no return

call me hyssop:
 wild shrub of uncertain identity

I would measure myself
 by fathoms:
 the span of outstretched arms

OFFERING FOR BÉLA RUBINSTEIN

At 10:15 every morning he took a bar of dark chocolate from his desk and ate a single piece. He went to work every day until he was ninety-four. With a steak knife he cut windows in cardboard boxes for my dolls. He poured the kiddush wine back in the bottle for next week. He wore the same gray cashmere sweater until the elbows disappeared. My grandmother sewed patches over the holes. He wore out the patches. He had no wrinkles because the war burned off a layer of his skin. He kept his first wife's dress and his first son's socks folded away in the back of a drawer. He called me his *kislány*, his little girl. On the rare occasion he got angry, in his imperfect English, he would say, "Come to hell!" He once mistook the kitchen oven for a crematorium. He hovered over Grandma as she cooked, adding water to the cholent, sugar to the salad. "The goulash is good. Much better than yesterday," he said to her at least once a week. And, every night, "Judy, have some soup," though she never did.

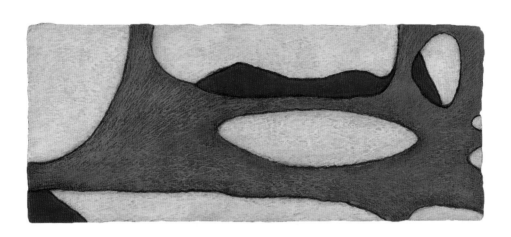

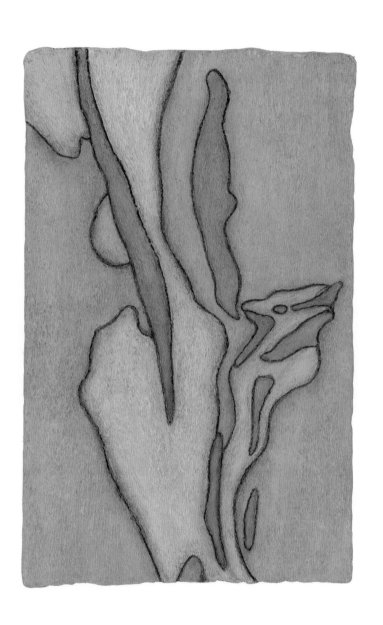

GRAIN OFFERING

who appointed the rooster to distinguish day from night
who removes sleep from the eyes
who makes firm our steps
who plumps the almond trees one year
and parches them the next

blessed are you who
what role did you have in this meal
whose feet crush grapes whose hands knead dough
who blues and blackens the moon

where we travel after death
is simple as growing wheat in a desert
we grind between millstones
to coarse flour

the question not who but what
we do with this bounty

OFFERING IN WHICH THE SPEAKER
TRANSCENDS TO THE THIRD PERSON

I put the kettle on, and in the time it takes to whistle, finish my morning ablutions. Next, tea in my favorite mug, bread in the toaster, coin of oil in the pan. I crack an egg and wait. Sometimes I listen to the radio, sometimes to the traffic below and planes on their way to LaGuardia. It's been months since my feet have touched the earth that spreads upon the waters. There I am above fourteen stories and a parking garage and a giant concrete block thrust into bedrock. A pat of butter spread on toast. She waits. Is about to take a bite as a driver descends on his car horn—she assumes it's a man—with impatience, and again with anger. The sound akin to a shofar, but more like a call to battle than repentance. Finally, he lets up and she notices her whole body has tensed. She exhales, and sits, and eats. The waters spread, the earth spreads.

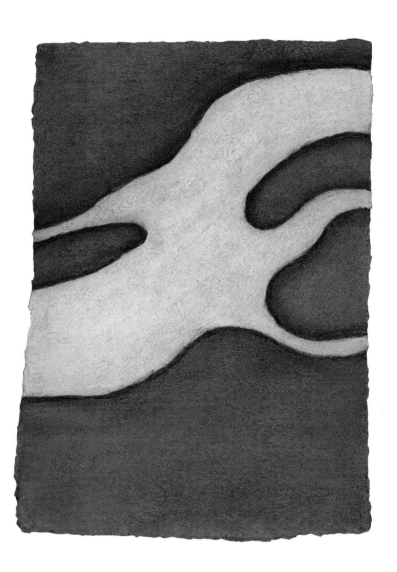

vow: to be kind and be kine and be kind

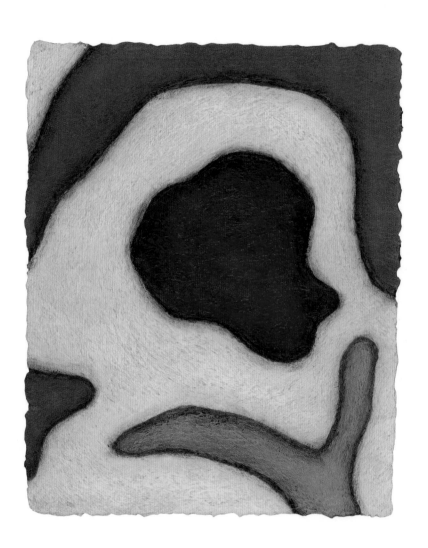

SALT OFFERING

I invite the stranger from a neighboring road
a woman as human as I if not more
to my table
thick challah slices and a pinch of the sea
that nations have gone to war over
and lamb stew with apricots and olives
we can't remember whose great-great-grandparents
planted the olive tree
does it matter
we both know to cure the fruit in brine
to remove bitterness
and now there is salt between us
a covenant of salt
and does not the ground
beneath our houses
lie down in the same direction

ORIENTATION OFFERING

Welter of keening, unrelenting, caught by thorny capers
who home in the crazing wall of limestone. Of the berries
small is best, the flowers Moses found tempting and
Mohammed considered a great treat. Also, a plant called
Drunkenness once used for love potions and smoked
for toothache or vestige of prophecy. Always face east.
I, ousted. Toronto: transplant, Brooklyn: transplant,
Jerusalem: transplant. As soon as the snow melts, sequela.
Who told you you were naked? Vestige of. Must there
always be upheaval. A time after the snow melts, suddenly
a fattened wall of green. I worship. A small voice. Who can
tell you which way to face? The sun.

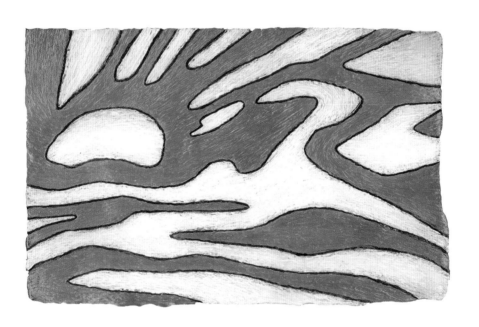

OFFERING OF SEVEN HEAVENS

> *Woe to the creatures which see and know not what they see,*
> *which stand and know not upon what they stand.*
> —*Tractate Hagigah,* Babylonian Talmud

[Shekhakim]

I was taught in school to stare at the stars
is idol worship.

In *Guide for the Perplexed,*
Maimonides says prophecy
is an expression of higher
intellectual capacity.

Clouds are set in motion.

[Raqia]

Frightened wise men vaulted the heavens
into something firm into firmament
like pavement like an upturned bowl
made by hammering thin a lump of metal.

[Zevul]

The stars are not fastened.
They don't wait for our sacrifice.
My tongue waits for sacrifice.

In sleep the smell of Jerusalem stone returns to me.

[Vilon]

Worshippers of Baal cut a bull
into pieces and cried out to their god
and this the bible dubbed idolatry.
When Elijah did the same, it was holy.

Roll up the apocryphal curtain
between prayer and incantation,
prophet and wizard.
Let the sun pass through.

[Ma'on]

The ministering angels allegedly
only sing at night. I listen. Nothing
but the stars.

I read the story of the daughters
of Rav Nakhman, who stirred
a boiling cauldron barehanded
without getting burned.

So-and-so is a witch—
the only information that can be drawn
from this statement is the relationship
of the speaker to the subject.

I am a witch,
that is to say,
mighty
and other.

[Makhon]

Treasuries of hail,
chambers of storm,
high dwelling place of dew.

Where most false prophets misstep,
the Talmud says, is that no two true prophets
have the same vision.

[Aravot]

Somewhere in the sky a door opens.

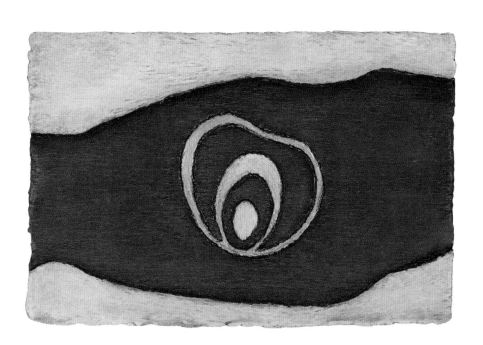

OFFERING IN THE HOLY OF HOLIES

when he enters
the sanctuary

past the acacia pillars
past the veil of
deep violet and pomegranate

to the innermost

the hairs on my arms
rise, a small forest

and all that is outer of us
(vanity of vanities)
goes hush

and we prostrate
before, for each other

and we are king of kings
and comes a song of songs

[congregation]: *the most holy place!*

where we meet face to face
our sweat, frankincense
on the brazen altar

this is atonement

in a windowless room
in the thick gut of dark
we profane, heaven
of heavens!

this is how we undo
transgressions we once did
knowing, unknowing

[congregation]: *the most holy place*

in the thick eye of dark
we invoke in whispers
a thinker of thinkers:
all real living is meeting

is dying is living

a sabbath of sabbaths

[congregation]: *the most holy place!*

in the gilded dark we sing
Blind Willie Johnson:
heaven's journey is almost over

and what was carried in

[congregation]: *to the most holy place*

must be carried out

when he exits
his face is radiant

and the work has just begun

VII

Make an altar of earth for me

—Exodus 20: 24

AVODAH

WORK

On the strawberry moon of my thirtieth year, I dig myself a grave. The late afternoon sun watches my shoulders, my labor of—what? Not love; a sense of necessity, this rite of passage. First step is to choose the shovel, square or pointed? The tool is a strange limb and the grass tenacious; after a few attempts at cutting through it, I give up. This is a crazy idea. But I don't want to live my next decade doubting my strength, so I pick up the shovel and try again, and I learn that earth will eventually break with repeated attack. I learn the power of a heel pushing down on the blade. To use all my body's weight. That the key to digging is not in the muscles of the back, oh no, it's in the legs and abdomen. Does it get easier? Easy isn't the word. Known, familiar, the work becomes. Repetition, incantation.

Sometimes a little violence is necessary. Before tilling the fields, Wolf said that the earth doesn't want to be disturbed, opened up. Our work on the farm is to do as little harm as possible, but it's harm, nonetheless. I keep digging. There is peace in sweat, holiness in work. This has been known since the beginning. I keep digging. Haven't gone this deep, not for potatoes, not for onions. I meet new layers of soil, brown to dark amber to brick as I go down. It's dry; Thomas says drought this summer. The soil is sandy loam in these parts, though we are far from any desert. Sand made by glaciers dragging granite, and loam, once limestone, once fishbones. This may or may not be true; I heard it from a good farmer and good farmers are, naturally, ecologists. *This* is fact: a sand grain can range from one-sixteenth of a millimeter to two millimeters. And the number of life spans to get there? I try to calculate how wide my hips are, measure with my eyes the dimensions of the hole.

In Hebrew, the words for worship and labor are one and the same. And if I tell you in this labor I am happy? For the first hour, at least. Then it is simply work and my emotional state has nothing to do with the heave and ho.

I do not dig the grave in one go. Deeper one day and deeper still the next. Blisters form from the shovel handle. I don't let myself wear gloves out of some notion that I need to bear the pain and wear the mark of the work. But why? Sometimes a little violence is necessary? The blisters are an exchange of force, mean that I have given some of my ease to the rite, and when they burst, in a small way, I too have opened.

I find as I dig: roots and then fewer roots, stones and then larger stones. Now I come to where the worms live, my shovel cross-sectioning their tunnels, little eyes along the wall of the grave. I pick out the worms and tuck them into the growing pile of displaced earth. Sacrifice: from the Latin combination of *sacer* and *facere*, meaning, respectively, "something set apart from the profane" and "to make." To make apart. I think of *havdalah*, which means "separation" and is the blessing I used to love, marking the end of the Sabbath and the beginning of a new week, recited over a many-wicked candle, wine, and cloves: "Praised are You, Lord, King of the Universe, Who distinguishes between sacred and profane, light and darkness, Israel and the nations, between the Seventh Day and the six days of creation." But sacredness for me is no longer about setting apart. It is ruinous to separate, to think it possible. All that I cling to and all that clings to me. The scared teenager, still in me, sick and praying; the child who found the world fearsome, yes, there she is, still in me; my mother's womb is in me; my grandparents and their parents, siblings, and children who didn't make it are in me; the scapegoat and what I have banished to the wilderness and the blood that has been salted away; the wandering souls; the leper and his cure, cedarwood and hyssop tied with scarlet wool; suet burnt, stacked skies, the loveless—they are all in me, still.

This is not a perfect resting place. No more than a few feet deep and not laid out in any meaningful direction like the path of the sun. I don't look up from the dirt, there is work to be done. After some hours, when I finally put down the shovel and straighten my bent body, I notice I'm panting and my shirt is damp with sweat. A small wind comes and I can't recall the last time I felt this pleasure on my skin.

Not deep enough but enough for now.

As the sun slips, I go out to the round pen once inhabited by horses. This is where I have dug my grave. I don't have white linen, the fabric of traditional Jewish burial garments, so I wrap myself in one of Grandma's old bedsheets, a floral pattern on what used to be white cotton. Liz once said to me, on poets: "We go to the graveside. That's what we do." She meant this as a metaphor. I lower myself into the hole, swaddle my feet, legs, head, and, after I lie down, torso and arms. As I settle into my new surroundings, I shiver, feeling insects exploring my body—real or imagined, I'm not sure. So much of my suffering has been of my own making. I had thought of myself as perpetually sunny until Moish, a Deadhead rabbi I met in Jerusalem, pointed out to me that I was, in fact, unhappy. I find that seventeen-year-old girl: alone in seminary in a warring country, seriously sick for the first time, her body in protest of the lack of care it was receiving. Scared, lonely, and depressed, before she knew what depression even was. I want to hold that child—she was just a child— and tell her not to be so hard on herself, to turn to someone more responsive than God for help, to go home. *Every offering is a return.* And here in a shallow grave in the land where I was born, I find myself beating my chest like I used to do in the Yom Kippur confession, repenting for my sins, when I believed: *Ashamnu*—We are guilty, *thump*. We have robbed, *thump*. We have spoken slander, *thump*. We have done violence, *thump*. We have revolted, *thump*. We have blasphemed, *thump*. We have rebelled, *thump*. We have transgressed, *thump*. We have oppressed, *thump*. We have gone astray, *thump*. We have led others astray, *thump, thump*, on my heart. My left hand moves to hold my right, which is clenched in a fist, and stops it from hitting my chest. It comes like the hand of a stranger. My fist loosens. *You are safe here.* I jolt from the sensation of things crawling on the sides of my face and realize I've been crying. I say goodbye to that girl who was afraid and ashamed and hurting. I say goodbye.

She leaves me and leaves me and the earth holds me and I think of the artist Ana Mendieta, who showed the trace of the body in the world, lay in tomb and riverbank and became them, and then, her end, a fall thirty-three stories out a window onto the roof of a deli. *You are safe.*

Often the act of sacrifice involves the destruction of the offering, but this destruction—whether by burning, slaughter, or whatever means—is not in itself the sacrifice. The killing of an animal is the means by which its consecrated life is "liberated" and thus made available to the deity, and the destruction of a food

offering in an altar's fire is the means by which the deity receives the offering. Sacrifice as such, however, is the total act of offering and not merely the method in which it is performed.

I sense animals surrounding the grave, my ancestors, or are they actual animals coming out as the night rises, drawing near in curiosity to wonder at this strange creature lying in the ground? A creature who should be thinking profound, transformative thoughts, but the only thing in my head is that Bee Gees song, *How deep is your love, how deep is your love . . .* My bones, fasciae, viscera, settle and settle to the breathing floor, and I remember Persephone, taken *beneath the depths of the earth* by *the one who receives many guests; the earth, full of roads leading every which way.* Maybe whoever wrote the "Hymn to Demeter" got the story wrong, maybe Persephone wanted to go down, to leave her mother, to be with the King of the Dead. How deep is your love?

I open my eyes now and then, a little less light in the sky each time. Sky, all there is from this vantage point. I'm no longer a human but a plant, placed in the ground, an old potato with eyes pointed upward. And I'll push up through the soil and grow into new potatoes. This process never ceases to amaze me. A potato, that's a tattoo I would get. No, I wouldn't, not any tattoo—because of A6876, my grandmother's number. Maybe she's there above the grave, in the body of a robin. She would always comment on the birds when we went for walks, "I wonder what they're talking about?"

Gods are hard for mortals to see, it says in the "Hymn to Demeter."

I listen to the living all around me in sky and soil, feel them buzz and rustle, the birds, crickets, toads, mosquitos, midges, ants, voles, they sing me to sleep.

In a sense, what is always offered in sacrifice is, in one form or another, life it-self. Sacrifice is a celebration of life, a recognition of its divine and imperishable nature. In the sacrifice the consecrated life of an offering is liberated as a sacred potency that establishes a bond between the sacrificer and the sacred power. Through sacrifice, life is returned to its divine source, regenerating the power of life of that source; life is fed by life.

It's nearing coyote time when I wake, and I have no idea how long I was asleep. Am I transformed? Have I died enough? I could go back to sleep and stay here all night, become a part of the night song. The total act of offering. Imperishable nature.

It's time to live, a voice says.

It's time to live, it's time to live, it repeats, until I understand.

And slowly I climb out of the grave and walk back to the house in a stupor. The night has grown thick with life, a full chorus: mosquito buzz, moth flutter, dog howl. Crickets scrape their wings together, fireflies glow to attract mate or prey. Somewhere an animal whimpers—there will still be pain. Life feeds life. When last season the currant bushes were suddenly naked, having lost all their leaves to win-ter moth caterpillars in a matter of days, and the apple trees, also infected, aborted their fruit, and I cried because I had failed to tend to them, Risa said to me, "We have to be comfortable with a certain degree of death." This is something one can only learn, I'm learning, from experience.

Back in the house, a hundred yards from my grave, I get into a warm bed and soon sleep, profoundly. According to a midrash, in sleep, like in death, the soul leaves the body. Every morning is a return. Sometimes I catch myself reciting the *Modeh Ani* upon waking, out of habit saying thank you to a God I no longer rec-ognize: "I offer thanks before You, living and eternal King, for You have returned within me my soul with compassion; abundant is Your faithfulness." In truth, don't we give to be received? When the sun reaches into my window, I open my eyes and throw off the covers. For most of my life I was afraid to sleep naked; still am, at times—what if the house catches on fire or someone murders me in my sleep? Brendan says to show more of myself. I didn't realize I was hiding in the distant landscape of Leviticus, and I hadn't let you, reader, see me where I am. I didn't know how. I was told to cover my elbows, knees, collarbones, and though I now wear tank tops and miniskirts, this fear of exposure, this shame of skin, has not been entirely unlearned.

It says in the Talmud that when God revealed Himself to the prophets, they didn't see Him directly; it was like looking into a dim glass. In the mirror I'm bewildered to see a woman fully grown.

What if I were to say, without any veil, any similes or miles between us: Look at me. Here are my scars, secrets, mistakes. This is my face in the morning without makeup, circles under my eyes so dark it looks like I got into a fistfight; look in my eyes, sometimes they're brown, sometimes they're green, sometimes, Ben used to tell me, sunflowers—odd, I know, but look closely . . . Here I am in Hillsburgh, Ontario, in ripped jean shorts and an old flannel shirt with the sleeves cut off and a bad haircut. And here is my day: pulling out unwanted plants so the wanted plants and their consecrated seeds can thrive, then laying down those unwanted plants around the wanted ones to feed them, in a process known as mulching, in an attempt to be a good caretaker, a taker of care. In other words, if you're looking for me, I'll be in the field, weeding.

Works Cited

Faherty, Robert L. "Sacrifice." In *Encyclopedia Britannica*. https://www.britan nica.com/topic/sacrifice-religion.

Nagy, Gregory, trans. "Homeric Hymn to Demeter." https://uh.edu/~cldue/ texts/demeter.html.

Too Long a Sacrifice

Ezra Cappell

> Too long a sacrifice
> Can make a stone of the heart.
> O when may it suffice?
>
> —*from "Easter, 1916," by W. B. Yeats*

WHAT CAN SACRIFICE POSSIBLY SIGNIFY IN OUR CULTURE OF INDIVIDU-
alism, our pursuit of self over community? What are its contours, needs, and
shapes? Do we feel its heat pressing up against our skin, forcing us to acknowledge
its presence, its insatiable desire to consume? "Qorbanot"—literally means "to draw
near." The ancients used the obligation of animal and grain sacrifice to draw nearer
to their God, and, through the sacrificial act, they fulfilled their communal obli-
gations beyond the self. Yet today, in our postmodern age defined by social media,
to what, other than self, might we be drawn?

Tobi Kahn's Hebrew name is Aaron. He is named after Aaron (Arthur) Kahn, an
uncle he never got to meet, a young man who during Easter week in 1933 had the
distinction of being one of the first Jews killed by Hitler's newly formed government.
At the time of his murder, Arthur Kahn was a promising student who was about to
embark on training for a career in medicine, where he hoped to dedicate himself to im-
proving the health of his community. Of those murdered in Prittlbach, only Arthur's
body was returned, in deference to his father (Tobi Kahn's grandfather Levi Kahn)
who had earned the German Iron Cross for bravery in battle during World War I.

Sacrifice: a giving of oneself for the greater good of society. Yet, as Yeats well knew,
too much sacrifice can "make a stone of the heart," turning emotion and feeling into
calloused, jaded responses to the suffering of others. Despite living and working in
the wake of tragic, generational sacrifice, rather than turn his heart away from hu-

man emotion and possibility, artist Tobi Aaron Kahn has shaped his formative story of familial pain and loss into an expression of understanding and emotional commitment. With heavily textured surfaces—through his work over many decades and the labor of his brush moving across canvas and handmade paper—Kahn transforms the absences and vacancies of history, the memory of murdered family members, the negative space of destroyed communities, into objects of contemplation and beauty.

Theologian and novelist Arthur A. Cohen famously said that diasporic Jews are the Holocaust witnesses who "bear the scar without the wound" (2). And yet the object of art, of poetry, is precisely *to* wound us. To make us bleed, at least metaphorically, so as to feel the pain *as if* we were there. Toward the end of *Leaves of Grass*, Walt Whitman warns: "Camerado! This is no book; / Who touches this, touches a man" (281) and those of us who pick up *Qorbanot* are pierced, changed, utterly altered by the experience.

Much like Kahn, Alisha Kaplan comes from a family of Holocaust survivors; each jagged line of her evocative poetry also forces us to contend with this history, with the knowledge of a world seared by pain and longing. Ancient Jews knew their seasons were framed by periodic sacrificial pilgrimages to the Holy Temple, but what about today? In a world of excess, how can we begin to understand the idea of *qorban*, of sacrifice? To take our firstborn child and raise a knife? To bring the fruits of our labors and relinquish our hard-earned bounty to the priests in Jerusalem? How are we to relate to that which animated ancient Jewish culture and community?

Today, is sacrifice measured in diurnal commitments: in our obligations to work, family, and community? Could this be our contemporary measure of sacrifice? In his epic poem *Gabriel: A Poem*, Edward Hirsch slowly reveals the story of the tragic death of his twenty-two-year-old son. Hirsch writes:

I did not know the work of mourning
Is like carrying a bag of cement
Up a mountain at night

The mountaintop is not in sight
Because there is no mountaintop
Poor Sisyphus grief

I did not know I would struggle
Through a ragged underbrush
Without an upward path

. . .

114

Look closely and you will see
Almost everyone carrying bags
Of cement on their shoulders

That's why it takes courage
To get out of bed in the morning
And climb into the day. (75)

From the midst of his grief, Hirsch stridently claims that the Herculean effort of staving off our extinction by moving forward into our day is enough—in a post-Holocaust world this monumental effort is perceived as an act of heroism, an act of sacrifice.

And today, in our post-Holocaust world, can art and poetry still lead us beyond self-interest? Can paint, paper, and words still move us, reach through our calloused, jaded twenty-first-century selves and inspire us to a life of service, a life of sacrifice? *Qorbanot* begins to answer this question as we embark on a journey into everyday sacrifices along with Tobi Aaron Kahn and Alisha Kaplan. Kahn's paintings and Kaplan's poems reveal a steadfast commitment to seeing things through. Take *Study for SAKEN ABI* (25) for example. Beneath the translucent surface of the painting, its multiple layers compel us to see the ways that the layers of underpainting push right up against one another—bodies, cultures, languages, ideas, all distinct yet defining that which is right beside it. Kahn's many layers of paint create texture, hinting at a past that is always within reach; it is the foundation upon which all else depends. All one needs do is, sgraffito-like, scratch the surface and a previous version of Kahn's art, of our selves, our style, our identity is revealed.

So, too, Alisha Kaplan's poems reveal a world coming in and out of focus, each page an act of discovery, a refusal to disengage with the messiness of the world. *Qorbanot* forces us to wrestle with theosophy: How can a benevolent God allow so much suffering to take place in the universe? One traditional Jewish explanation to profound human suffering has been the concept of *hester panim*, literally, a "turning away of the divine face" that keeps watch over the world. Yet instead of turning away from the history of suffering and a life of confusion, *Qorbanot* represents an active engagement with the world on its ever-shifting terms. In this volume, the work of an established artist and a beginning poet speak to each other on the page and communicate powerfully to readers and viewers, inscribing difference and celebrating diversity. This small, mighty book represents an acknowledgment of the precarious state of post-Holocaust Jewish identity and, much like so many foundational Jewish texts that have come before, it, too, is steeped in heretical questioning.

When I was a boy, my grandfather, who was a grandson of the Modzitzer rebbe, taught me many Hasidic *niggunim*. At first, he would advise me to just hum the *nig-*

gun, the tune, before dealing with the words. He explained that many of the most beautiful Modzitzer *niggunim* did not even have words; they were *d'veykus* (literally, "to cleave") tunes, which through wordless repetition would help draw people nearer to God. Eventually my grandfather would teach me the words to these songs, but by focusing on the tune first, before the words, he explained, the Hasidic masters would intertwine emotion and intellect together. To this day I cannot forget a particularly haunting melody: *kol ha-olam kulo*, which contained one pithy phrase repeated over and over again: "All the world is a narrow bridge; the key is to fear nothing."

Instead of recoiling from the world, from their messy and tragic history, which as Yeats cautioned is often the result of too much suffering, Kaplan and Kahn instead get out of bed in the morning, roll up their sleeves, and fearlessly get to work. And much like those Hasidic songs of old, *Qorbanot* also works on us most powerfully when taken piecemeal, before, eventually, in our mind, painting and poem are brought together.

In "Grain Offering" (3), a heretic muses on her contemporary *qorban*, her sacrifice. As in ancient times, the speaker attempts to draw near to something or someone besides herself, but the speaker has no grain or animal to sacrifice, and in a revealing commentary on our postmodern condition, she says: "all I have to offer is myself." Kaplan's poems evoke a haunting contemporary perspective on the ancient rite of sacrifice—even her *qorban*, her attempt to render an experience outside her own subjectivity, only leads right back to the self. Perhaps the *d'veykus*, the drawing near, for the reader of *Qorbanot* takes place not on either side of the page, not in Kahn's painting alone, nor in Kaplan's poem, but rather this closeness is enacted in the space between the two. In this book, artist and poet speak to one another across the printed page, and somehow Kahn's paintings and Kaplan's poems begin to communicate with one another and, much like the Hasidic songs of my youth, taken together, painting and poem persistently reach us, the viewers and readers of their work.

In so doing, each leaf of *Qorbanot* becomes a midrash, filling in the gaps between painter and poet—generational and artistic—and working together they extend our understanding of ancient Jewish rituals and, ultimately, our self-perception. The scent of Kaplan's "heretical" sacrifice "curls in the air not rising beyond the date palms." Kaplan's poem extends Rashi's midrash on the first sacrifice in the Hebrew Bible, where, unlike his brother Abel's accepted sacrifice, the smoke from Cain's tainted offering did not rise straight to heaven; instead, it was rejected by God as the smoke dissipated on the wind. Cain's anger, shame, and jealousy of Abel would find expression in the first murder recorded in the Bible as he slew his own brother.

As in Rashi's commentary on the Hebrew Bible, so, too, does Kaplan's heretical sacrifice unloose violence: Kahn's menacing painting, *Study for* AYALA *v. 1* (31), seems to respond in kind to Kaplan's poem about Cain and Abel, "Offering from Which There Is No Turning Back" (28). Is this an image of a blood-soaked hand of Cain stained from fresh violence against his own brother? Murder, vandalism are so much a part of the world glimpsed in *Qorbanot*. But so is beauty and promise. The same blood-red hand frames and shadows a desert of calm, sifting sands. This book seems to say, Yes, there is a violence at the center of our culture, but Kahn's paintings and Kaplan's poems force us to confront that violence and, in containing it, fencing it (*asu syag la-torah!*), prevent that violence from seeping into and coloring everything else in our world. In painting after painting, Kahn warns us that although violence is unavoidable, we will be judged by how we handle that legacy of loss, of sacrifice, that we have been bequeathed. Or as Kaplan asks in her poetry: How will we navigate our selves, our lives through the difficult terrain of our history, our identity? At the center of this book is an attempt to, as Maurice Blanchot says, "write the disaster," to find a new means of expression that will represent the supposed unrepresentable event of the Shoah through paint, ink, and paper.

I believe Kaplan and Kahn, working together in this remarkable volume, have bequeathed to us a new way of approaching the disasters of history, as well as the personal disasters that, as Hirsch reminds us, require heroic efforts simply to continue and move forward with our lives. If just getting out of bed in the morning can be seen as an act of postmodern heroism, how much more so the act of creativity, the daily call to paint and to write, to rewrite and to paint over, again and again? Is this not a form of sacrifice? What these poems and pictures reveal is a world in which multiple perspectives are not just tolerated, but, working together on the page, they forge a new path, a new *derech* toward understanding the unlikely twenty-first-century persistence of ancient Jewish rituals and identities.

In the poem "Masada Offering" (11), Kaplan reflects on the *derech*, the Orthodox path of ritual praxis that her family wishes she remain firmly upon. Instead, she hikes the ancient trail leading up to the stone fortress of Masada, built thousands of years ago to protect a previous generation of rebellious Jews. She listens to Jimi Hendrix as she climbs and she recognizes she cannot blindly follow tradition, but, like the ancients before her, she must forge her own path. So, too, in Kahn's intense painting, the foreground and background continually shift because of the play of color. We see this in the stunning painting *Study for* QUADAR (2). At the center of the painting, in muted green hues, is a pubis framed by other labial forms that surround and frame the central image while water flows throughout. In Kahn's work,

there seems to be a constant battle between what is there on the handmade paper or canvas and all that is not readily apparent but fights to assert itself, nonetheless. Resisting others' conception of received tradition, the *mesorah*, Kahn's paintings and Kaplan's poems forge their own *derech*, their own path within that tradition.

The poem across from Kahn's *Study for* QUADAR is titled "Grain Offering," which itself refers to an ancient sacrifice, an oblation given voluntarily by community members and not necessitated to atone for any specific sins. An alternate name for grain offering is "gift offering," and taken together, painting and poem do form a sort of gift, an offering to us, a reminder of our persistent need for sacrifice. Upon studying these texts, readers are bequeathed a bold mandate to follow their own difficult path through the "ragged underbrush" of our collective and personal histories. What essential quality of ourselves will we sacrifice in the furtherance of our shared mission? Ultimately, that question lies at the heart of this project; it is the gift and the obligation that animates this transformative volume of art, poetry, and commentary.

In "Peace Offering" (17), Kaplan asks: "am I guest or host"? And Kahn's painting opposite, *Study for* VEIKUT, reminds us that we are perpetually both; that in our postmodern lives, roles and identities can be interchanged and that the work of one can be taken up by another. Kahn's paintings show us time compressed; through the persistent labor of his brush, hard, sharp angles have been softened, like isinglass beneath the force of water, reminding us of the passage of time and generations. In *Qorbanot*, between image and text, Kaplan and Kahn have found a new way to approach an understanding of the Shoah and, in so doing, the world, which each new generation, including our own, has inherited.

Go and learn: Read, view, and be changed. *Qorbanot* leaves a mark upon each reader, an afterimage that persists even as one's eyes close on Kahn's last painting, paired with Kaplan's poems, a stone of the heart becomes the rock of ages, recalling the noble sacrifice of the past and the vital work we still have before us today.

Works Cited

Blanchot, Maurice. *The Writing of the Disaster*. Translated by Ann Smock. Lincoln: University of Nebraska Press, 1995.

Cohen, Arthur A. *The Tremendum: A Theological Interpretation of the Holocaust*. NewYork: Crossroads, 1981.

Hirsch, Edward. *Gabriel: A Poem*. New York: Knopf, 2014.

Whitman, Walt. *Leaves of Grass*. 1892. New York: Signet Classic, 1980.

Yeats, W. B. *The Collected Poems of W. B. Yeats*. 1956. New York: Macmillan, 1970.

In the Spaces Between

Lori Hope Lefkovitz

THE "ROOT OF *qorban* IS *to draw near*" (3), ALISHA KAPLAN TEACHES IN THE first poem in this collection. Sometimes translated as "offering" and more usually as "sacrifice," the etymology for *qorban* (draw near) roots us in an ancient tribal imagination when one sat down to a meal with God to foster intimacy across dimensions, bringing your offering to God's Temple home. The reader might miss having fallen into a small space between word and translation: between the "making sacred" of *sacrifice* and the "drawing near" of *qorban*. We have also fallen, unwittingly, into the space in time that opens as words' meanings evolve. Once, in a gift exchange economy, these words carried fully positive connotations. Giving guaranteed receiving, society depended on the circulation of offerings, and hoarding was illogical.

Now, *qorbanot*, like sacrifices, are saturated with the sense of loss. In our free market economy, laden with the losses of Jewish history, we make our sacrifices of blood, labor, and time, in studios and on battlefields, sometimes immense sacrifices, often reluctant, with an eye on an unfathomable cosmic balance, wondering if all the losses of life and history are giving us purchase on some mysterious benefit, for ourselves or those we love, for the future in which we have invested, whether through labors of production or reproduction.

The reader of this volume falls into the space, too, between the *qorbanot* about which we read in Leviticus, the Talmud, and in the commenting traditions (to which Kaplan alludes in its details with learned comfort, so unobtrusively that you won't know if you are missing a reference)—the complex sacrificial system with its grains and animals, fully consumed by fire or shared in community—and the ways

in which Judaism has translated that ancient system into a new idiom, whether into prayer (as the *mincha* offering has become the afternoon *mincha* service) or table ritual (*challot* and salt, for example, situated on the postrabbinic altar, the dining surface at the center of a Jewish home). These ritual spaces across time are bridged in gold, from Bezalel, who, infused with God's spirit, crafted the original Tabernacle and the precious objects described in Exodus, to Tobi Aaron Kahn, whose artistic corpus includes exquisite material iterations and reinventions of Judaism's sacred past.

There is both affinity and tension between the poems and the pictures, and the artist, Kahn, and the poet, Kaplan, each in different relation to their shared lineage from the ancient priestly class. Kahn, the son of refugees, remains always mindful that he is named for his uncle Arthur who was murdered in 1933, both men named in Hebrew "Aaron," after the first priest, first *kohane*. Kahn allows that as both nominal priest and artist he experiences the privilege of imitating the Creator and channeling blessing. Kaplan breathlessly enumerates in "Heave Offering" the more limited permissions and restrictions for the *bat Kohane*, the daughter of a priest, concluding with the words: "I am the daughter of a priest no longer" (55). A woman, younger, Kaplan draws us into her life experiences and inner landscape, with competing devotions to her liberty, her desiring body, and the traditions of the people who raised her in a regulated social world of judgments and inequality, such that her first utterance, poised between query and declaration, is "am I heretic" (3). Evoking the *eruv*, not in so many words, "the fine wire" that creates the legal fiction of an enclosure, tongue-in-cheek, she writes, "they taught me in school / constraint is freedom" (13).

Yet Kaplan, too, makes her offering, drawing the goat near, placing a vow, a hand, "between the goat's horns / before it's slaughtered / as if to say I'm sorry" (8), reminding us that the root Q-R-B—"draw near"—also gives us the verb for laying on hands, drawing near animals for sacrifice and priests about to be ordained, as the biblical Aaron ordained (drew near) his sons. Priests as sacrificial goats, and a persistent confusion between who eats and who is eaten. In the multimedia universe in these pages, we encounter irony, paradox, and ambivalence, manifesting spaces between what we think we know and what we cannot know, spaces between deeply felt commitments that contradict one another, spaces conceptually inherent in alienation, apology, and memory.

We find a full literal, literary re-creation of ancient rites and Jewish history translated into contemporary psychological experiences, needs, and anguish. Here, a modestly rebelling teenager in the desert climbs the well-maintained trail up Masada. Quietly conjured is the story of Jewish martyrdom in once-upon-a-time,

as the poet-speaker ascends the winding path and mentions that she is considered to be "off the path" (11), a modern idiom that describes lapsed Orthodox Jews. The paradox is not lost on us. Another poem resists the classification system of *kashrut* for casting away "that which defies classification" (32). By alluding to the anthropological interpretation of ancient food rules as a rejection of matter out of place, Kaplan exposes that systems of meaning inevitably designate some bodies and our bloody emissions as extraneous, defiling, or outside the margins. Other poems celebrate "taking in" pleasure in contrast with the more usual surrendering, "giving up" of the *qorban*. In these devotional poems, in the tradition of the late Yehuda Amichai, the poet observes (maintains consciousness of) the Sabbath while breaking it.

Poignantly, there is a way that the young poet Kaplan does stand in for Kahn's one-time personal friend, Israel's great poet Amichai. Kahn, when he was a young man, had talked with Amichai about collaborating on a book of paintings and poems. That the project never actualized opened the space for this new collaboration with roles reversed—Kahn now the elder established artist—transforming that regret. Like Kahn's other memorials, and like all memorials, *Qorbanot* is a transmutation of loss, a statement of abiding witness to that which cannot be recovered. Kahn's obsession with memory reminds us that we live in the space between fleeting experience and its recollection, between presence and absence. These visualizations comprise a documentary history of *qorbanot*, from biblical blood to the blood spilled in history to the lifeblood of our own moment. The paintings on handmade paper, many years in the assemblage, beautiful, fluid lines, saturated in color, not illustrative but perfectly antiphonal, express emotion through motion, evoking cells, bodies, blood, life, longing, loss, and paternity.

Alternately enraged, guilty, regretful, and affectionate, Kaplan connects with her mythic and immediate ancestors. Recalling the *Aqeyda*, God's command to Abraham to sacrifice his son, Isaac, and alluding to the midrash that Sarah screamed six times, Kaplan recounts a list of grim news stories about parents who heard God commanding them to sacrifice their children until, in a turn of sympathy, she comes to her own mother, who "believes that to be a mother / is to protect your child from harm / and forgive all your child inflicts" (67). The speaker, in any number of poems, carries the burden of her mother's suppressed screams. The poems are haunted by animal slaughtering and people burnt as holocausts by Nazis.

Here is a tiny tribute to a grandfather who called her *kislány*, his little girl, cut windows for her dollhouse, and "once mistook the kitchen oven for a crematorium" (84). And here is a grandma showing her a photograph taken on May 5, 1945,

of rows of women in dresses she had newly sewn from abandoned Nazi bedlinens, saying over rugelach, "We began, mamaleh, to be human" (81). *Kislány, mamaleh,* is language of love to the beloved third generation, the guilt-ridden daughter who resists, yields, and ultimately also transcends, escorting us on an interpretive ascent into each of Jewish mysticism's seven heavens. For Kahn, who has written about the power of art to "transmute darkness," color and light transcend time and space, a through line to the Source by way of the living sources.

I have my own associations with *qorbanot*, most powerfully to my maternal grandfather, Samuel, a profoundly reticent, pathologically anxious, and humble man, who worked in Barton's candy factory when I was a child. His religion included unwavering devotion to me and a grave pride in his status and obligations as a descendant of the Levites of Leviticus, servants to the priests. Called to the Torah with the honor reserved for his tribe, he stepped into a time-honored parallel system that conferred him with dignity. My grandfather knew of burnt offerings: his parents, his seven siblings, their spouses, and their many children all murdered by fire. Only recently, decades after his death, when my younger daughter, Samara, visited her namesake's childhood home in Krosno on a college trip, a home that she said was the most beautiful place they had seen in Poland, did I understand that my Grandpa Sam had grown up in wealth and privilege. And there is the space between the world of there and then and that of here and now, between what came to be and what might have been.

The *qorbanot* were many, too, on my other side. Recently, standing on the arrival platform in Auschwitz where my father had parted from his mother and two brothers and a sister, not knowing that he would not see them again, I had a glimpse into my always joyful father's broken heart. Kaplan's revelation of the sacrifices endured by parents, and the sacrifices they later chose to make for us, and the weight of remorse that accompanies the struggle to break loose, resonate in me, vibrating chords in the space between the daddy who unfailingly smiled by day and nightly dreamt of Carpathian Mountains forever left behind.

Confession: I love the Levitical rules about how and when to choose animals or grains, about when one eats with the priests or in community, about which offerings were burned in their entirety and which were intended to be food for communal meals. I love the lull of the Levitical repetitions about pouring, dashing, and spilling blood over various parts of the altar and the gross materiality of cultic rites and their contrast with the antiseptic way we slaughter and acquire meat today, neatly wrapped in cellophane in white freezer compartments in grocery stores, keeping us at a far remove from the messy business of throat slitting and the collection and

dispersal of warm lifeblood. Just as clean, white institutions often keep us at a remove from illness, aging, and death, we bomb populations by drones, at a remove from the effects of our weapons on creatures with lifeblood. I love the blood, in particular, as described in these rites because blood demands consideration of the meaning and value of life.

The rules of *qorbanot* include offerings made when you feel whole and others as requests for forgiveness; the priest offers some on behalf of an erring community and others to atone for his own mistakes; some are appropriate for the rich, others for the less wealthy. The system is democratic in that the rules are public, not secrets between God and the priestly elites. It is socialist because equal benefit is derived from unequal gifts, as long as the offering matches the giving capacity of the donor. The system is respectful of the individual's private relationship with God in that the regulations work to mask the character of certain sacrifices so that, for example, a sin offering would appear to an outside observer as if it might be a wholeness offering. It is about conscience: one offers a sacrifice if one neglected to respond to the announcement to come forward with information that might help a criminal investigation.

Qorbanot are about the emotional dimension of life: bad intentions or failed attention, crimes of neglect or omission. One sacrificed for inadvertent bad behavior, the system indicates, because inadvertent misdeeds can indicate a kind of laziness, a lapse in one's attention that amounts to thoughtlessness, and the sacrifice represents a commitment to paying attention so that one might not offend God by being oblivious to the needs or feelings of others. The *chatat* and *asham*, which expiate for unwitting crimes, also represent a concern for communal sanctity.

Kaplan and Kahn's *Qorbanot* is beautiful in the imagining, in the words and the pictures, that render the paradox of life and death, and the spaces between who we have been and wish to be; Judaism as it has been and is yet to be; in constraint and freedom, longing and loss, the sometimes delicious, sometimes suffocating aroma of smoke, and the bittersweet tastes of grain and guilt. It is about the freight of inheritance and the complexity of loving one's own blood.

What We Can Offer

Sasha Pimentel

IN TOBI AARON KAHN'S PAINTING ON HANDMADE PAPER, *Study for* KANAKI (71), we are watching a daughter kneel before her father. Her body accordions down while her hands strain up, and he is clutching her fingers and palms so tightly that their four hands form the shape of a single, swollen cord.

Someone else is looking on, a silhouette between them.
In her poem "Burnt Offering," Alisha Kaplan writes:

The last time my grandmother saw her father, he blessed her and said:
Eat whatever you are given and be among the first to offer work. (70)

She says this in the poem in *Qorbanot* beside the painting from which, *inside* which, we are watching this girl and her father. We do not want to watch them. We are too aware of, as we sight the coloring in their taut hands, this history. But the painting is unfolding in its own narrative time, in which we must exist too, in the present tense of its own revelation. It is a moment so intimate we should not be inside it. But we *are* inside it. So we begin to understand how a gesture as simple as a holding of hands means urgency.

Together, Alisha Kaplan and Tobi Aaron Kahn have shuttered us within this moment—it is moving through us as we inhabit it—and her words slough off their distance, her past tense transforming into our prsent.

*

There's a moment in Philip Levine's poem "The Mercy" that always stuns me. A seaman on a ship to Ellis Island extends a piece of orange to a nine-year-old girl for whom an orange is strange fruit; he teaches her its name while smallpox ripples through the crew and passengers, the girl listening to prayers leaking up in strange tongues along with her own Russian and Yiddish—the hope held in language there—and after all the loss, she hefts a single orange and her suitcase into New York. We don't know if the man who "gave her a bite and wiped her mouth for her / with a red bandana and taught her the word, / 'orange,' saying it patiently over and over" lived or died (75). The poem is tinged by the weight of communal loss, her mouth reddened by it. But what matters in this poem is the *offering* made in the center of suffering, that concrete thing handed from one person to another that remains, even after the poem has ended, and after the materiality of the thing itself has eroded: the spirit of gift that is a mercy, will forever linger with this child who'll become a woman.

In this beautifully collected book, Kaplan understands that a poem calls out by partitioning the silences of the experience from which it speaks: "Eat whatever you are given and be among the first to offer work," she writes (70).

Here, a mercy is conferred through language: advice, not fruit, fastens father to daughter. Written in only two lines, the page almost subsumes the small poem, but then we understand what is unsayable, what is so unbearable and true all at once that it cannot be said aloud, can never be fully held in language. Here, in the middle of the Shoah, in what we can guess is a camp, all a father can offer his daughter are a blessing and one sentence to counsel her survival, what he and she already know, what he and she will know, swallowed by silence and white space. "Eat whatever you are given," he tells her, whether that will come in the form of strangers' kindnesses, or soup, false coffee, and black bread, the imperative syntax hinting to Paul Celan's "Schwarze Milch der Frühe" (32)—black milk of daybreak, "black milk of morning we drink" (46–47)—the soot in Kahn's sky emanating from the three copper-colored figures, the outlines of their bodies.

What is offered cannot be a concrete thing (what, possibly, of the material world could a father give to his daughter as he's being forced away from her?); it is his language, then her work.

But these are offerings that, despite the deaths encircling them, persist, survive generations as narratives so even the speakers know them. In Levine's poem, the girl is the speaker's mother, but in Kaplan's book, she is the speaker's grandmother, who in a later poem also titled "Burnt Offering" can be read as the woman, Judit, who, at the dinner table, "in the same voice she uses to describe her trip to the supermarket,

/ [tells . . .] how she almost got hanged in Auschwitz for picking wild blackberries" (74), or, in the poem "Offering to Béla Rubinstein" (84), can no longer eat soup.

But in the earlier "Burnt Offering" (its title piercing because the author implies that even this moment of scission between father and daughter is just one in a series, one of many terrible burnings), the girl becomes that metallic, copper figure in Kahn's *Study for KANAKI*: the daughter's body folding to her father, supplicant as she grasps his hands, their two bodies clasped together by color. Her legs, which must be pleated to the ground before him, and the rest of him—his bowing head and torso—are suggested, but remain unseen, off canvas.

Instead, the *punctum* in the composition lives in their joined hands, that single dark cord that is their holding on to one another. The next moment, what will rend them, is so painful it must remain invisible, is this painting's own unsayable-unseeable, and the third figure looms in the pewter background, is positioned so closely to their hands in such darker and rigid textures that the figure seems to be watching them, perhaps as witness, perhaps to break their joined shape.

Of course it's pareidolia—led by Kaplan's poem—through which I imagine these figures, and the tension in their joining and their separation in Kahn's painting. Kaplan and Kahn realize our need to perceive from the abstract an image, or narrative, and their collaboration between painting and poetry so clearly appeals to, and forges how, we perceive one art form through another. How we see Kahn's paintings, each on their own handmade paper, is transformed by Kaplan's silences and her language, and we press in and into each of Kaplan's poems with the unspoken deep feeling and organic desire of Kahn's colors, brushwork, and gesso. "[T]he root of *qorban* / is *to draw near*" (3), Kaplan begins this book, and as each of the pairings draw nearer to each other, they reach out to us as offering too, activating the root of "presence," the here, the now, in the word "present," what is given: what Jorie Graham calls "the sensation of real time," when a work of art's action "has crossed over into our time," our days, when we "cannot read the painting without being inside the terms of the painting" nor read the poem without colluding with its language.

In this way the act of offering requires an understanding of separation as much as communion, and an awareness of how to trespass that separation. How to, in reaching, extend to that which is greater than oneself and one's circumstance, whether to the divine, as fruit to a child, as a last sentence to one's daughter, as a painting to a viewer, or as a poem to a reader. The primary purpose of *qorbanot* after all, whether the Hebrew is translated as "offering," or as "sacrifice," is not to proffer sacrifice to an angry god for redemption but to draw nearer to that which

is sublime, as a burnt offering is meant to escalate to sky. Unlike how "sacrifice" is often conceived of in other religions, this kind is meant to, from something material, transform to something of the spirit.

It is utterly appropriate then that a book titled *Qorbanot* be written half in poetry, and stroked half in paint.

Poetry sees with an unflinching eye that which is not normally seen and reveals its subject with exactitude, even if what it reveals is how much it hurts to be alive when the sky trembles with smoke. It uses image and rhythm as fulcrum, thrusts its lines forward with the momentum of sight and song against silence, against forgetting, against the white space of the page that resists the poem and threatens to subsume it. But the lines reach across anyway, wrestling across the ragged margin between poem and page, the poem profoundly aware that the language it sings is wrought from silence, that its body is constructed in relation to how it is exposed to space. Its ambition, its linguistic leaps can stretch us and our logic, propel us, as Kaplan does from "what the body is to do upon waking" (23) to "what if song entered the mouth instead of leaving it" (35), to "faces / in the moon" (64), to Judit, pointing to a photograph from May 5, 1945, to where she has taken "the cloth on which Nazis / had slept and sweated" and made ten gingham dresses from it, a plate of rugelach on the kitchen table as offering to her granddaughter, Judit pointing to the photograph and saying, of the transformation of the material, "We began, mamaleh, to be human" (81).

Through intimacy, one person to another, a poem is a gift that resonates its lyric, its story, or its memory past the canvas of the page and into the reader's own consciousness; unclasps in that reader through its offering that which is deeper, compassionate, and true. Art, at its best, textual or physical, is capacious, treats the spaces of exposure and risk from which it speaks as capacious too, reaches for such precise renderings of the world with generosity and nuance so that the reach becomes a celebration of life. "The line breaks," the poet Major Jackson says, "because we break and reconstitute ourselves towards some terminus of exaltation," the artist working from an understanding that it is by pressing ourselves against risk, exposure, that we become more humane and widen our knowledge of who we can be: how we can transform, transfigure, exalt.

Look, again, even closer, at Kahn's painting, *Study for KANAKI*: though the figures' outlines emanate a nimbus of darkness that distinguishes each shape from one another, seen as bodies, these figures hold light in their centers. Kahn's renderings through *Qorbanot*, which quiver one into another, touch tensely, and form their own horizons, always carry light. A master not just in his craft but in his vision, Kahn already knows what I as a younger artist in poetry am still trying to sight:

how to ennoble the image by shifting its tone; dignify experience; succor from suffering, mercy.

Last week, I traveled to New York City carrying this manuscript, *Qorbanot*, as a sheaf of printed papers before it became the book that you now hold. Researching this essay, I'd meant to place my binder-clipped photos of Kahn's paintings up to one of his paintings in person, but when I found the installation, KHAYLET, 2005, in the lobby of the UJA Federation on East Fifty-Ninth Street, it shook what I thought I already knew, and what I thought I would learn. Viewing, so closely, and in real time, the five person-sized canvases that held together one painting, I could sense the sloughing off of the kind of closed intellect I'd carried into the building with me, which wanted to categorize and apportion. What transfixed me, thrust into my consciousness then from Kahn's painting and so changed me, was the profound emotion of the work's vision: its perception so abundant that the horizon it sees and seeks is larger than five canvases can bear. Linguistically, "KHAYLET" unwinds from *Tekhelet*, the color in the Talmud that ought thread through the four corners of a prayer shawl to remind its wearer of the sky. But the great blue of Kahn's painting does not ripple as sky. It is instead a vast body of water—the sky in his painting white as a page—its blue coursing against the scorched curves of brown that one can imagine is land. It is a *feeling* of blue whose wholeness comes, when a person walks right up to it, from many kinds of blue, the infinitely shifting tones.

It is a feeling of blue as much as in *Study for* KANAKI there is still the suggestion of a sky somewhere under the pewter background, though we cannot sight it; we only know our own want for it as the setting and the heavy air surges around that daughter, on the ground, kneeling to her father. It is the feeling of illumined and uncontainable color coursing through Kahn's *Qorbanot* and the breath-song of poetry inhaling, exhaling, in Kaplan's *Qorbanot*. "What if song entered the mouth instead of leaving it," Kaplan asks us in another "Burnt Offering": "and what of the sacred nostrils // you say this offering is not death but a transformation / from one kind of existence into another," and in so saying, she offers us from the body living and the body dying an exalted, capacious space: "within me are openings openings / and hollows hollows // all that can cross a threshold" (35).

What is sublime, Kahn and Kaplan thus imply, is not only that which is above us, but that which comes from us, and that which is swirling around us.

We can carry it from the world in which our bodies already live; we can swim in it, and drink of it; we can grieve it and revel in it; can commune in it: and we can offer it to one another.

Works Cited

Celan, Paul. "Death Fugue," translated by Jerome Rothenberg. In *Paul Celan: Selections*, edited and with an introduction by Pierre Joris, 46–47. Berkeley: University of California Press, 2005.

Celan, Paul. "Todesfuge." In *Poems of Paul Celan: Revised and Expanded*, translated by Michael Hamburger, 30–33. New York: Persea Books. German original from Celan, Paul. *Mohn und Gedächtnis: Gedichte*. Stuttgart: Deutsche Verlags-Anstalt, 1952.

Graham, Jorie. "The Art of Poetry No. 85." Interview by Thomas Gardner. *Paris Review* 165 (Spring 2003): https://www.theparisreview.org/interviews/263/the-art-of-poetry-no-85-jorie-graham.

Jackson, Major. "Five Questions with Major Jackson." Interview by Alexandria Hall. *Washington Square Review*, blog, February 26, 2017, www.washingtonsquarereview.com/blog/2017/2/26/five-questions-with-major-jackson.

Levine, Philip. "The Mercy." In *The Mercy: Poems*, 73. New York: Knopf, 2000.

Acknowledgments

THANK YOU TO STATE UNIVERSITY OF NEW YORK PRESS, IN PARTICULAR EDITORS Ezra Cappell, who was instrumental in making this book possible, and Rafael Chaiken.

Thank you to contributors Ezra Cappell, Lori Hope Lefkowitz, Sasha Pimentel, and James E. Young for their insightful words.

Thank you to the Ontario Arts Council and Denis de Klerk at Mansfield Press for support for this project, and to Ben Post for his generous donation for the printing of color images.

Thank you to Samuel Kim for his invaluable help with the layout and design.

Thank you to editors of the journals and magazines *Lilith*, *Cosmonauts Avenue*, PANK, PRISM *International*, and *Written Here: The Community of Writers Poetry Review 2017*, for first publishing a number of the poems in this book.

Tobi would like to thank Emily Bilski, Leonardo Drew, Douglas Dreishspoon, Sharon Florin, Steve Fredman, Mark Mitchell, Klaus Ottmann, Aaron Rosen, Richard Shebairo, and Mark Tykocinski, for their steadfast support of his work. And Nessa Rapoport, his amazing partner in life; their children, Josh, Mattie, and Doria; and his sister, Felice Kahn Zisken, for continuing to inspire him every day.

Alisha would like to thank her tribe at the New York University Creative Writing Program; her teachers Catherine Barnett, Yusef Komunyakaa, Deborah Landau, Sharon Olds, Matt Rohrer, and Rachel Zucker; her mother, Rochelle Rubinstein; and friends, who all guided her through writing *Qorbanot*.

Notes and inspirations for the poems can be found online at:
www.alishakaplan.com/qorbanot.

Images

The images of *Qorbanot* are devotional offerings, visual meditations created over 30 years. They represent a quest to distill what we remember into essential images, archetypes that allow the heartbreaking past to be transformed by imagination into a resonant sanctuary in a still-struggling world.

I am named for my uncle, Arthur (Aaron) Kahn, murdered on April 12, 1933. Arthur was a 21-year-old medical student when he tragically entered history, the first Jew to be killed by the Nazis. As an artist and his namesake, I am obsessed with memory and its imperatives, always aware of time's passing, of the possibility of loss, an abrupt reversal of safety.

And yet, the tribute that the dead ask of us is not only to mourn their irreplaceable existence, but to live with joy and fruitfulness. These paintings, not previously exhibited or published, are an invitation to release enduring memory into a capacious future, for their sake and for ours.

—*Tobi Aaron Kahn*

All artwork in acrylic on handmade paper.

About the Authors and Contributors

TOBI AARON KAHN is a painter and sculptor whose art has been shown in over 70 solo museum exhibitions. Works by Kahn are in major museum collections, including the Solomon R. Guggenheim Museum, NYC; Houston Museum of Fine Arts, TX; The Phillips Collection, DC; Albright-Knox Art Gallery, Buffalo, NY; Minneapolis Institute of Art, MN; Yale University Art Gallery, CT; Pennsylvania Academy of the Fine Arts, Philadelphia, PA; and The Jewish Museum, NYC. His traveling museum exhibitions include *Tobi Kahn: Metamorphoses; Avoda: Objects of the Spirit; Microcosmos; Tobi Kahn: Sky & Water;* and *Tobi Kahn: Sacred Spaces for the 21st Century.*

Kahn's commissioned installations include "Shalev," an outdoor sculpture, in New Harmony, IN; "Emet," a meditative space for the HealthCare Chaplaincy, NYC; two Holocaust memorial gardens, in La Jolla, CA, and Tenafly, NJ; the sanctuary ark doors, murals, and ceremonial objects for Congregation Emanu-El B'ne Jeshurun, Milwaukee, WI; "M'AHL," a floor installation in the exhibition *Rendering the Unthinkable,* 9/11 Memorial Museum, NYC; a meditative space for Auburn Theological Seminary, NYC; and an installation of paintings and outdoor sculpture for the campuses of Thomas Jefferson University, Philadelphia, PA.

Kahn also communicates his vision through his passion for teaching. For over 30 years, he has taught fine arts at the School of Visual Arts, NYC. He co-founded and facilitates the Artists' Beit Midrash at the Streicker Center of Temple Emanu-El and lectures extensively at universities and public forums internationally on the importance of visual language and on art as healing.

ALISHA KAPLAN received an MFA in Poetry from New York University and a BA in English and Creative Writing from Barnard College, and she is currently pursuing a Certificate in Narrative Medicine from Columbia University. Kaplan is a workshop facilitator for the Toronto Writers Collective and a member of the Persephone Project. She has taught creative writing at New York University and has been an editor for *Narrative Magazine* and *Washington Square Review*. Honors she has received include the Hippocrates Prize in Poetry and Medicine, a Rona Jaffe Fellowship, and a Lenore Marshall Barnard Poetry Prize. She is also a winner of the W. B. Yeats Society of New York Poetry Competition and the Eden Mills Writers Festival Literary Contest. Her writing has appeared in *ence*, *Lilith*, DIAGRAM, *Chicago Tribune*, PRISM *International*, *Carousel*, and elsewhere. She splits her time between downtown Toronto and Bela Farm in Hillsburgh, Ontario.

*

EZRA CAPPELL is Professor of Jewish Studies and English at the College of Charleston. Cappell previously served as the founding director of the Inter-American Jewish Studies program at the University of Texas at El Paso, and he is a recipient of the University of Texas Regents' Outstanding Teaching Award. Cappell received his BA in English from Queens College (CUNY), his MA in Creative Writing from The City College (CUNY), and his MPhil and PhD in English and American Literature from New York University. Cappell teaches and publishes in the fields of twentieth-century and contemporary Jewish American literature. Cappell has published numerous articles on American and Jewish American writing and he is the author of the book *American Talmud: The Cultural Work of Jewish American Fiction* and coeditor of the book *Off the Derech: Leaving Orthodox Judaism*. Cappell is a frequent lecturer on Jewish American culture and Holocaust writing, and he serves as editor of the SUNY Press book series in Contemporary Jewish Literature and Culture.

LORI HOPE LEFKOVITZ holds the Ruderman Chair in Jewish Studies at Northeastern University, where she directs the Humanities Center and the Jewish Studies program and is a professor of English. Her book *In Scripture: The First Stories of Jewish Sexual Identities*, was a 2010 finalist for the National Jewish Book Award. A graduate of Brandeis University, Lefkovitz received her PhD from Brown University and was a recipient of a Woodrow Wilson dissertation fellowship, a Golda Meir postdoctoral fellowship at Hebrew University in Jerusalem, a postdoctoral fellowship at the Institute of the Philadelphia Association for Psychoanalysis, a

senior Fulbright Professorship at Hebrew University, and an honorary doctorate from the Reconstructionist Rabbinical College (RRC). Lefkovitz has been an associate professor at Kenyon College and the Gottesman Professor of Gender and Judaism and founding director of Kolot: The Center for Jewish Women's and Gender Studies at the RRC, which developed Rosh Hodesh: It's a Girl Thing! and the website Ritualwell.org. Her books include: *The Character of Beauty in the Victorian Novel, Textual Bodies: Changing Boundaries of Literary Representation*, and (with Julia Epstein) *Shaping Losses: Cultural Memory and the Holocaust*. She and Rabbi Leonard Gordon are the parents of two grown daughters.

SASHA PIMENTEL was born in Manila, Philippines, raised in the United States and Saudi Arabia, and is the author of *For Want of Water: And Other Poems* (2017), selected by Gregory Pardlo as a winner of the 2016 National Poetry Series. *For Want of Water* is also the winner of the 2018 Helen C. Smith Award and was long-listed for the 2018 PEN Open Book Award. Her poems and essays have recently appeared in the *New York Times Sunday Magazine, PBS News Hour, American Poetry Review, Literary Hub*, and *New England Review*. She is also the author of *Insides She Swallowed* (2010), winner of the 2011 American Book Award, and a holder of the Picador Guest Professorship in Literature at Universität Leipzig in Leipzig, Germany. She is an associate professor of poetry and creative nonfiction in a bilingual (Spanish-English) MFA program to students from across the Americas at the University of Texas at El Paso, on the border of Ciudad Juárez, Mexico.

JAMES E. YOUNG is Distinguished University Professor Emeritus of English and Judaic and Near Eastern Studies at the University of Massachusetts, Amherst, where he has taught since 1988, and founding director of the Institute for Holocaust, Genocide, and Memory Studies at UMass Amherst. He received his PhD from the University of California in 1983. His teaching and research areas include narrative theory, cultural memory studies, Holocaust studies, and visual culture. Professor Young is the author of *Writing and Rewriting the Holocaust* (1988); *The Texture of Memory* (1993), which won the National Jewish Book Award in 1994; *At Memory's Edge: After-Images of the Holocaust in Contemporary Art and Architecture* (2000); and *The Stages of Memory: Reflections on Memorial Art, Loss, and the Spaces Between* (2016).